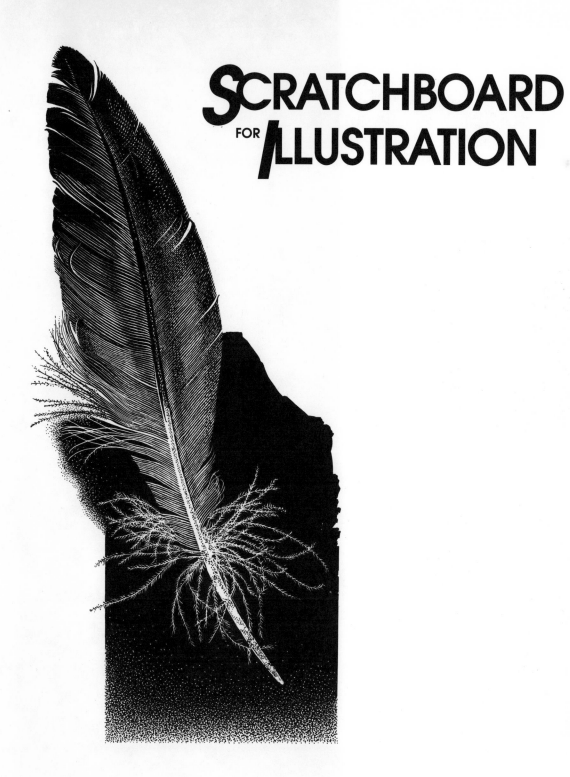

# SCRATCHBOARD
## FOR ILLUSTRATION

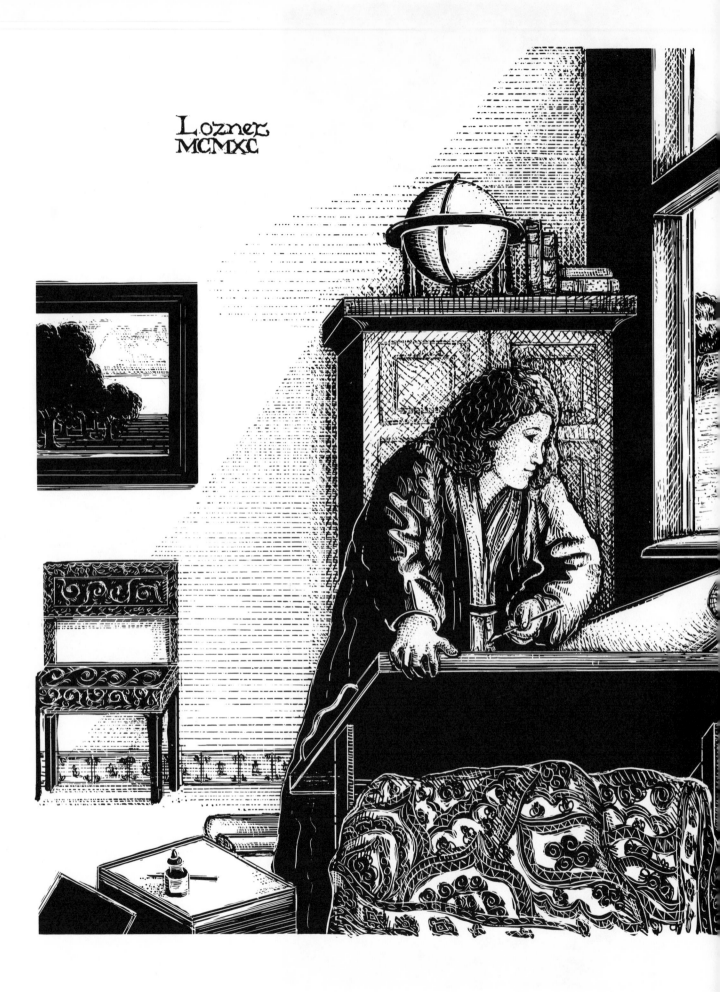

Lozner
MCMXC

# SCRATCHBOARD
## FOR ILLUSTRATION

RUTH LOZNER

**WATSON-GUPTILL PUBLICATIONS**
NEW YORK

Copyright © 1990 by Ruth Lozner
First published in 1990 by Watson-Guptill Publications,
a division of BPI Communications, Inc.,
1515 Broadway, New York, N.Y. 10036

Library of Congress Cataloging in Publication Data
Lozner, Ruth.
  Scratchboard for illustration/by Ruth Lozner.
    p.   cm.
  1. Scratchboard drawing—Technique. I. Title.
NC915.S4L69   1990
741.2′9—dc20                                          89-49107
                                                     CIP

ISBN 0-8230-4662-1

Distributed in the United Kingdom by Phaidon Press Ltd.,
Musterlin House, Jordan Hill Road, Oxford OX 2 8DP
Distributed in Europe, the Far East, Southeast and Central Asia,
and South America by RotoVision S.A., 9 Route Suisse, CH-1295 Mies,
Switzerland.

Manufactured in U.S.A.

1  2  3  4  5  6  7  8  9  10 / 94  93  92  91  90

Edited by Grace McVeigh
Graphic production by Hector Campbell

# ACKNOWLEDGMENTS

I want to acknowledge my debt to the illustrators whose works adorn this book. These artists and others responded with generosity and enthusiasm to my requests for examples of their work and explanations of their techniques. Without their cooperation, this book would not exist.

Much gratitude to the University of Maryland, Department of Design, for its clerical and office support. Thanks especially to Bonnie Griffin, whose patience and wizardry with the word processor helped me through countless versions of the text and to Brenda Roelofs for her assistance. I am extremely grateful to Violet Gaunce, whose help with the correspondence and organization was indispensable.

I would also like to thank Glorya Hale, who believed in me and this project and provided the initial impetus for me to attempt it; the editors at Watson-Guptill, whose skills put on the final polish; and my parents, Blanche and Reuben Lozner, who have always been my greatest fans.

This book is dedicated to my students—the hundreds and hundreds I have taught, and who at the same time have taught me.

# CONTENTS

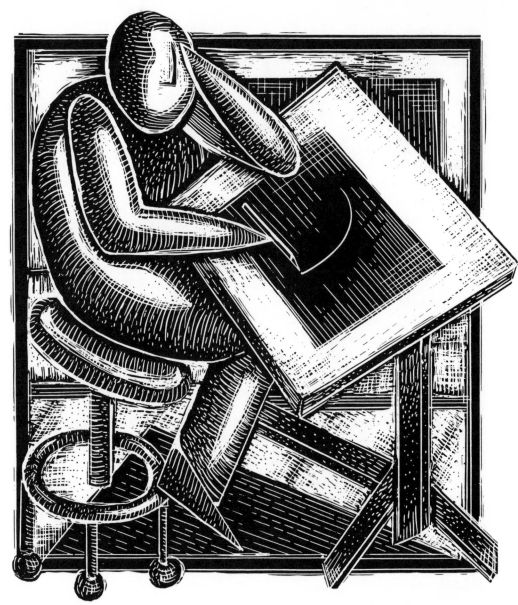

RUTH LOZNER

*The scratchboard technique can adapt to any drawing style.*

# PREFACE

Represented in this book are many of the finest contemporary illustrators from the United States and other countries. Their work appears mainly in books, newspapers, magazines, and advertisements. Influenced by artists, printmakers, and illustrators of the past, today's illustrators have reinterpreted the traditional method of scratchboard. Although some of the styles used are quite reminiscent of past masters, many of these artists have exercised greater license, working more interpretively, less literally, and with a new sense of freedom of expression. The range of styles is quite broad—from meticulous superrealism to expressionistic or nearly abstract. The realism often tends to be less photographic, more conceptual, and more personally stylized. The expressionistic work reflects the current trends in the fine art world. These artists have broken old rules and pioneered new ones. Each can teach a studious artist something different.

Let the illustrations in this book serve as inspiration. Keep in mind that the possibilities of scratchboard are infinite. Learn from the variety of materials, tools, and methods shown throughout this book, and then begin your own investigation for a personal approach. Learn from others by study and learn from yourself by practice.

What is being explored in this medium, both as revival and as evolution, I find very exciting to witness. It is my pleasure to share with you my own enthusiasm for the art of scratchboard and guide you in the exploration of a fascinating and practical art form.

*This illustration, used as a business card, imitates the look of a woodcut.*

RUTH LOZNER

RUTH LOZNER

*Scratchboard lends itself well to achieving the nostalgic look of engraving.*

# INTRODUCTION

One of the most natural and primal human instincts is to leave one's mark in a surface. Artifacts from tens of thousands of years ago reveal lines incised into stone, bone, or earth. Countless examples of *sgrafitto* exist, such as hieroglyphs, cuneiforms, and pictographs, wherein drawing, decoration, or information was produced by the act of scratching lines into a surface. Numerous parallels can be seen from such diverse sources as architectural decoration incised into wet colored plaster to scrimshaw drawings cut into ivory and then rubbed with ink. Humans have always been compelled to engrave on a variety of surfaces—children love to draw with their fingers on frosted windowpanes or in sand at the beach; graffiti artists scrape their personal messages into trees, wet cement, or the surface of dirty automobiles.

The primitive methods of communication by engraving evolved into more sophisticated art forms. The resulting media with its accompanying tools, materials, and processes became more controlled and refined with each stage of development. A brief overview of the development of the graphic arts will provide a historic context for scratchboard illustration.

With the invention of the alphabet, man could broaden his base of communication. And through illustration, his words could be enhanced with imagery. As civilization progressed and, with it, literacy, ways of creating the vehicles of communication had to be developed to fill the needs of a greater population. Books, hand-scribed and individually illuminated, simply could not fill the demands of the masses. Relief printing has been credited to the Chinese as early as the third century B.C., and examples of block printing appeared in Egypt in the second century B.C. Woodcut, in its commonly understood form, had become by the ninth century A.D. a popular way to reproduce imagery and information in multiple editions. Gutenberg's invention of the movable-type printing press and cast type in the mid-fifteenth century furthered the use of woodcut as a means of incorporating illustration with typography in mass production. Various intaglio printing processes (where the line is incised and filled with ink and printed) continued to develop as methods of reproduction of imagery. Engraving in both wood and metal, and etching, were methods often used to reproduce existing artwork originally done in other media, such as painting and sculpture. Hand-produced wood engraving became widely

*Incised marks could have been the first art form.*

RUTH LOZNER

used in the late eighteenth century for just such a purpose. Like the woodcut printmaker, the engraver had to follow the artist's detailed drawing or painting by meticulously cutting away all but the black line that would be left raised on the block to be inked and printed. Lithography, introduced in the late eighteenth century, could produce artwork with subtle halftone gradations, an advantage over the line work of intaglio. Its disadvantage, however, was that the artwork and type had to be printed separately on different presses. Illustrated matter on wood engraving could be printed simultaneously with the type on a letterpress. By the late nineteenth century, illustrated magazines had become quite popular. Added to that, the unprecedented volume of newspapers, handbills, broadsheets, posters, books and official documentation rendered hand-engraving and lithography techniques artistically unsatisfactory and economically impractical.

Introduced more than one hundred years ago, scratchboard is a unique medium and technique that evolved out of this world of printmaking. Quite simply, the modern scratchboard is a piece of cardboard that has been coated on one side with a layer of specially prepared hard white chalk. Black ink can be rolled or sprayed onto the surface, or it can be left in its white state, which allows the artist to draw directly onto it with black ink. The ink is then scratched through the sharp stylus of knife, creating a white mark or line by exposing the chalk underneath. A strongly contrasted black-and-white linear drawing results.

Karl Angerer, an Austrian lithographer from Vienna, has been credited with developing the first scratchboard (or *scraperboard*, as it is called in Europe) around 1864. Introduced in this country in 1880 by Charles J. Ross, a printer in Philadelphia, the medium grew out of the needs of these artisans to find an inexpensive alternative to metal plates or lithographic stone. Drawings for illustrated journalism and advertisements could be easily and directly drawn on the scratchboard, and corrections made quickly and with little harm to the surface. The result was that by the late 1890s the boards coated with a smooth layer of chalk had become very popular among commercial illustrators.

From the early part of this century through the 1950s, a great number of newspaper and magazine editorial and advertising illustrations, as well as illustrations for adventure and science fiction pulp magazines, were done in scratchboard. For certain kinds of medical and scientific illustration, as well as for some editorial work, scratchboard or a closely related medium has been used continually to this day.

Commercial artists have always had to respond to the requirements of the publishing and advertising industries. The contemporary editorial illustrator continues to seek out satisfying and successful techniques to fulfill the need for effective visual imagery in the mass media. The 1980s have witnessed a revival in the popularity of scratchboard, as more and more artists are discovering its practical advantages and artistic power. In the early 1980s I began to notice a number of illustrators (all of whom are represented in this book) who were working in this medium. I was greatly attracted to the dynamic impact of their work, the strength of contrast, and the beautiful variety of line.

I have included in this book a range of contemporary professional scratchboard illustrations being published today. Each artist has gravitated to scratchboard for reasons that are as different as the artists themselves and the techniques they employ. Maybe it is the atavistic instinct from our ancestral image-makers that makes the medium so compelling. Perhaps it is that scratchboard is a nostalgic link to illustrators of the past, or because it bears the look of printmaking without the technical difficulties, or that many illustrators today enjoy the physical interaction with the medium or the aesthetic results that it yields—whatever the reasons—the number of scratchboard artists is growing daily!

# WHY USE SCRATCHBOARD?

Although scratchboard is primarily a black-and-white medium, many of us have had very early experiences with a simple kind of color scratchboard. In many grammar school art classes, the art teacher instructed us to create a colored line drawing by first making a crude kind of scratchboard surface. First, we laid down randomly colored wax crayon marks on a piece of cardboard. Then we covered the marks with a layer of India ink or tempera paint. With a fairly sharp instrument, we drew by scratching off the black ink, revealing the multicolors underneath. It was great fun! It was magic! And it produced beautiful results very easily.

In a way, scratchboard is reminiscent of this elementary school technique. It is charmingly old-fashioned in this age of computer graphics and information systems. In appearance, the medium of scratchboard can suggest woodcut and wood or metal engraving. In fact, often it is deliberately imitative. Scratchboard uniquely combines the skills, techniques, and effects of several other media, such as painting, pen and ink, intaglio printmaking, even low-relief sculpture. It has many aspects of these media, as well as several significant differences and advantages that contribute to its popularity.

Scratchboard, which is easily incised with any sharp tool, can be fairly simply corrected with additional ink and scratches. As a direct drawing method, it allows the final positive black and negative white areas to be visible at all times in the drawing/scratching process. The absence of these characteristics in the wood and metal printmaking media can be frustrating for the artist, who might realize mistakes only in the finished product after an extended inking and printing process. The cutting of the metal plate or woodblock for the printmaker is la-borious and time-consuming. Actually, many of the line and textural techniques achieved with ease in scratchboard, such as crosshatching and fine detail, are impossible in woodcut or linoleum, where errors are often irremediable. A printmaker must also "think in reverse," since the drawing is actually printed backwards. The scratchboard artist is free of these concerns and can be confident that the illustration will be faithfully reproduced in high-quality printing.

Scratchboard, unlike traditional pen and ink, allows a greater variation of lines. It is quicker and easier to get a "negative" line, or white line, in a black area in scratchboard than to leave the line open and untouched by the pen and ink or to work back into black areas with opaque white paint. Many artists whose work is primarily "positive" drawing in pen and ink (that is, black line on a white surface) find that they can enhance their work with the additional instances of the scratched line for unique effects. Also, the scratchboard clay surface allows for an extremely clean, tight, and controllable line that regular drawing paper cannot provide. Although the scratchboard artist has only one original, as with any pen and ink drawing, historically scratchboard has been a medium for use as commercial illustration where the original is mass-produced in vehicles such as newspapers or magazines. Its reproduction quality is excellent and economical.

The broad value range in scratchboard is achieved through black line only; therefore, the halftone effect of middle tones is obtainable through the inexpensive cost of a line shot, or line engraving. It can be photographed and etched onto the offset press plate along with the type, both printing 100 percent black with no halftone dot screen neces-

sary. Any photograph or artwork that has continuous-tone or halftone would have to be converted into these tiny dots in order to be printed. Therefore, for this reason, scratchboard illustration is excellent for use on newsprint or cheap pulp stock, where the line screen used for reproduction is open and crude and the paper highly absorbent of the ink. Often, the illustrations can be drastically reduced in scale and still hold the detail, since the original line is extremely crisp. The lines in the drawings, if not too fine, will not bleed or clog up in reduction.

The scope of possible effects obtainable in scratchboard is tremendous. As with any medium, it will reflect the artist's creativity and technical skill as well as individual imagination and style of expression. The versatility of the medium is

exemplified by the examples in this book—work ranging from tight mechanical renderings to freehand stylized illustrations. The illustrations were done for a variety of purposes and clients— editorial illustrations for books, newspapers, and magazines; advertising and product illustration; scientific and medical illustrations; collateral work such as posters and greeting cards; comic books; and personal and unpublished work.

Each artist in this book has gravitated to scratchboard for different reasons. And each has found a particular style and technique. My own reasons for choosing scratchboard are personal yet perhaps not unique. I had been working for many years as a professional illustrator in the traditional medium of pen and ink. Although I found it to be a direct and immediate way of working, I eventually grew tired of it. I needed more involvement with the medium. Principally an oil painter, I found that I missed the sense of interaction with the surface and medium that I could achieve with paint on canvas and could not with pen and ink. In addition, I wanted to develop a new and different "look" for my illustration work.

In the competitive field of commercial illustration, a personal and identifiable style is what makes an illustrator distinctive and therefore more marketable. As a creative asset, technique must become automatic so that the artist can attend to pictorial problem-solving and free self-expression and exploration. Technique is a means to an end. It takes work, patience, and persistence.

The medium of scratchboard is extremely interactive and constantly surprising and satisfying. Remember that the quality of drawing is of greatest importance, and its unique characteristic of being relatively easy to correct can liberate you to take risks. It is, of course, the particular vision, content, concept, skill, passion, and drive that contributes to success, but by and large that vision must be expressed in an individualistic way.

*A great number of newspaper advertisements in the 1920s and 1930s were done in scratchboard.*

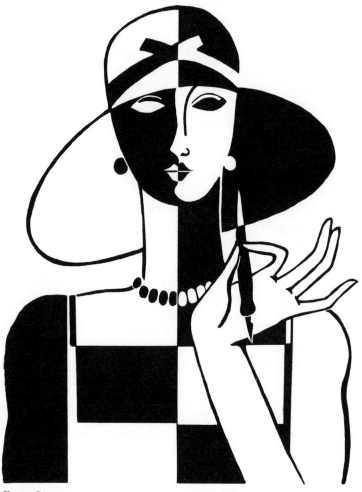

RUTH LOZNER

# MATERIALS AND TOOLS

One of the pleasures of scratchboard is that the materials and tools are simple and accessible. A trip to the art supply store should provide the basic necessities of ink, brushes, pens, scratchboard tools, and scratchboards themselves. For large volume work, artists often order boards directly from the distributor or manufacturer or through their art supply store.

## BOARDS

A number of commercial scratchboards of varying quality are available. Basically, scratchboard is composed of hard cardboard, free from wood pulp, spread with either a layer of a mixture of kaolin, gelatine, and glycerin or a layer of a natural substance of white China clay or chalk similar to porcelain (or calcium carbonate). The clay is mixed with water and natural animal gelatine glue for adhesion and chemicals to maintain suspension and retard fungal and bacterial growth. The wet clay mixture is applied by machine, dried between each coating, then calendered and compressed under extreme pressure. The polished clay surface is then embossed with a texture or left smooth. The resulting fragile surface is responsive to scraping and inking.

The local art supply store will probably stock a thin poster board or cardboard (8 or 10 point) coated with either a plain white China clay surface (white scratchboard) or coated with the white clay that is covered with a thin layer of India ink or chemical black dye mixed with a natural gelatine and bonded to the surface (black scratchboard). These boards are marketed under names indicating grades, such as "domestic," "budget," "student," and "classroom." A 9″ × 12″ sheet might seem inexpensive, but price is one of few benefits of using lower-grade boards and it is not a large one at that. Since the surface coating of chalk is quite thin (about 150 microns), there is little room for manipulating the mark or line and, more importantly, little allowance for making spontaneous changes or corrections by reinking or rescraping. Furthermore, these boards are quite pliable and bend easily in transit, which causes the chalk to chip or flake. These boards should be mounted on another piece of cardboard as backing. If the boards are older than a few months, the black ink tends to crack, which prevents the artist from scraping crisp sharp lines. In short, the results of drawing on these less expensive boards are rather limited. To avoid frustration, it is best to use these products for beginning experiences and not for finished pieces on which you will be spending much time.

To produce professional-quality work, it is wise to use superior-quality scratchboard products, available from larger art supply stores or large art supply distributors. (Preparing a homemade traditional white chalk surface seems to be extremely impractical. Supplies are difficult to locate and expensive.) Several imported European brands of excellent quality are readily available. Essdee Scraperboard made by British Process Boards Ltd., Canson scratchboard (both imported and distributed in the United States by Morilla), and Paris scratchboard (imported and distributed by Scratch-Art® Company) are three of the products I recommend. In particular, the Essdee (professional-grade) is most satisfactory. The chalk surface is consistently smooth and sensitive and will allow for extremely fine scratches. The surface is quite thick (300 microns) and can accommodate very careful scraping and reinking for corrections up to three or four

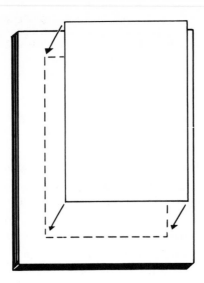

*Here the scratchboard is mounted onto a backing board.*

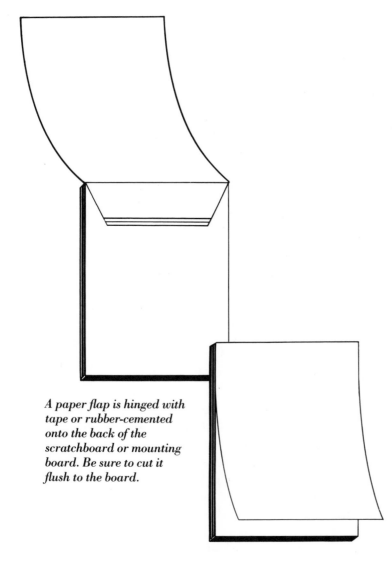

*A paper flap is hinged with tape or rubber-cemented onto the back of the scratchboard or mounting board. Be sure to cut it flush to the board.*

times. The baseboards are double-ply (40 point), and if you use small pieces, they do not necessarily require additional mounting.

You will most likely be cutting the boards into smaller pieces. This is more economical and makes them easier to handle. Since 19″ × 24″ sheets are expensive, each piece will be worth saving and using. Small spot illustrations can be done on what might be considered "scrap" pieces. While you will need some extra white space around your drawing, you may be frugal in the size of the pieces you cut and use.

Essdee also makes boards that are grained and stippled by means of mechanically embossed patterns available in both black and white scratchboard. These are reminiscent of some of the textured boards manufactured by the Ross Company of Philadelphia, which are no longer available. (See chapter 13 on nontraditional black-and-white illustration.)

Also available from Scratch-Art Company is a sketch pad of a thinner-gauge scratchboard, which is conveniently portable and responds well to many drawing media. This grade of scratchboard can also be put through certain photocopy machines. (See page 137 for a discussion of photocopies as a means of reproduction.) A good idea for the young artist who enjoys instant gratification is a black scratchboard with colored surfaces underneath, which can safely be scraped with the sharpened wooden sticks, also provided by the Scratch-Art Company.

Black scratchboard is identical to white scratchboard, except that it is precoated with a black surface. The opaque black India ink or dye coating, which is rolled on or very thinly sprayed on by machine, consistently covers the entire surface. All the commercial companies listed above make black scratchboard. It is interesting to note that most artists working in the scratchboard medium find that white scratchboard is generally more useful. Perhaps it is surprising to most people, but much more illustrative work is done on white than black scratch-

board. White scratchboard allows you to use your own black coating and apply it to certain areas with brush or pen. You will find that you will not need to cover the entire surface of the board, that the shape and size of the inked area will be determined by your drawing and desired look. This will eliminate the need to laboriously scrape away large black areas that will be white in the final work.

Since there is no sealant on top of the white clay surface, it will not be resistant to any dirt or oil from your hands that could prevent the ink from coating the surface properly. Therefore, you should get in the habit of frequently washing your hands and placing a piece of clean paper under your hand while working to prevent the surface from being damaged. The clay surface is hygroscopic and therefore very susceptible to moisture. On a very humid day the surface might not respond as well as you wish, but air conditioning in your studio should take care of most of the moisture in the air. If moisture has compromised the surface, lay the boards for a short time on a heating pad to dry them out or on a desk where they can get exposure to direct sunlight, or in a slightly warm oven for a few minutes or in a microwave oven on a medium/low setting for a few seconds. Do not use boards that are even slightly damp. It will be impossible to cut a crisp line into the surface. If you are working on a lower-grade board or a large sheet of the higher grade for an extended period of time, it is wise to double-mount the board onto a baseboard, since there is a tendency for the boards to curl back to the unpainted side when they become the least bit damp.

## PROTECTING THE BOARDS

Any illustrator will tell you that an illustration tends to get brutalized on the way from the studio to the printer. It can be dropped or jammed into a messenger's bag or simply fall off the drafting table. Take all precautions—especially when using the lower grade of scratchboard—by mounting the scratchboard onto an-

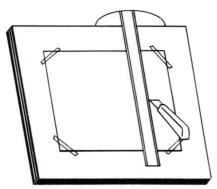

*Place the head of the T square at the top of your drafting table. Use a utility knife to cut the scratchboard into smaller pieces.*

other piece of illustration or mat board using a double dry-mounting system. On the scratchboard, the image area should always be centered with a minimum two-inch border around it. The mounting board should still be larger by at least another three inches on all sides. Coat the back of the scratchboard (the non-glossy side) and the front of the mounting board with a layer of thinned rubber cement or other waterproof glue. Let both surfaces dry and then press them together. You might also use a dry-mount press to adhere the thinner scratchboard to a backing board with dry-mount tissue. The heat of the press will also reduce any moisture that might be present in the clay surface. Store the scratchboard in flat files or portfolios with acid-free blotter paper in between. Be sure to "flap" the boards with a cover sheet of paper after you have started to draw on the board and especially after you have completed the illustration. The flap is a protective sheet of tracing paper and/or cover stock, cut to cover the entire board (not just the image area) and folded over and hinged on the back of the board with tape. I recommend glassine, Mylar, or a heavyweight parchment tracing paper that will not stick to the surface.

*Black scratchboard is identical to white scratchboard, except that it is pre-coated with a black surface. Textured board is available in both black and white.*

# CUTTING TOOLS

A variety of scratchboard cutting tools are available. The most common are Hunt nibs. These *sgraffito* nibs, which will fit into a wooden or plastic pen holder, are available in two shapes—a sharply angled diamond shape and a broader more curved spade shape. The two nibs, especially the spade-shaped one, will yield different thicknesses of line depending on the angle and pressure with which you draw. Also available are English "scratch knives" (available from Oasis Art & Craft Products, Ltd.) that come in four differently shaped nibs that fit into a plastic holder. The holder is held in the same way as a regular pen and the scratched line is achieved by stroking the tool toward you. These nibs are very useful, but they are inconsistent in sharpness even when new and become dull sometimes after one drawing. A Carborundum sharpening stone or oil stone used in conjunction with oil is useful for keeping nibs sharp. Take care to keep the bevel on the underside of the nibs intact when sharpening. Also commonly available is a needle stylus set into a wooden handle (by Grifhold, Essdee, or Scratch-Art). This tool is limited in use—a consistent very thin line is the only one it produces—but it may serve certain purposes very well.

Needle Cutter is a product by Grifhold consisting of a metal holder with two ends into which two of eight very sharp knife blades can be inserted. This tool is initially very sharp and retains its sharpness and points longer than the *sgraffito* nibs. The tool comes in a handy case that holds the blades and metal handle. The needlelike blades vary in shape and size and, like the Hunt nibs, yield a variety of lines depending on the angle and pressure of your stroke. Since you can adjust the length of the blades in the holder, it is comfortable to work with and allows you to further personalize the tool.

Surgical blades such as the Bard-Parker #11 or #15 are quite useful and can be used in an X-Acto knife handle. These blades can be found through medical supply companies. Etching needles, scalpels, X-Acto knives, and Ulano knives are also excellent. The most popular X-Acto blades for scratchboard are #16, #10, #11, and #24, although all X-Acto blades can be used for different effects. Wood-cutting or linoleum-cutting tools (although not those used for deep gouging) are available in graduated sizes that will cut a larger swath. Even dental tools yield successful marks.

For multiline work, the Scratcher tool by Scratch-Art is available. This tool is a small oval piece of steel alloy with seven fixed projections with one, four, six, ten, and twelve small sharpened ridges of various widths. When dragged across the black ink, this tool will scratch tiny parallel cuts. It is quite awkward to use, but once you find a comfortable position, you can achieve an effect similar to that of painting and engraving in broad strokes. Engraving tools, such as #25 and #60 that yield multiple parallel lines are also useful, although you may find that your drawing strokes have to change.

Many artists have found these tools adequate, but they have discovered or invented other tools to achieve their own identifiable style. A tiny piece of hacksaw blade (about a quarter inch) or a tied bundle of metal-wire brush bristles held in a handle, such as the needle cutter or X-Acto holder, can produce exciting multiline effects. Almost any sharp metal instrument can be used. All the artists in this book have their own favorite tools. They became familiar with them by experimentation. After finding one or two that were most comfortable, they now use them almost exclusively. You will want to find a tool or several tools that will allow you to scrape freely, expressively, and with little pressure. Experimenting and practicing with many tools will familiarize you with techniques as well as help you to discover your own personal style.

*Needle cutter.*

*Hunt* sgraffito
*nibs and holder.*

*X-Acto knife
blade #11 and
holder.*

*English scratch
or scraper knife
blades and
holder.*

*Scratcher tool.*

## INKS

The best ink for applying black surfaces or lines on white scratchboard is a good-quality black India ink, such as Higgins or Pelikan, or another black waterproof drawing ink, such as Koh-I-Noor technical pen ink or Japanese Sumi ink. The ink must be rich black and saturated with pigment. A transparent ink or dye or watercolor will not work. These media will stain the clay surface through to the base and prevent the possibility of making a scratched white line.

Acrylic, black plaka, or gouache will not work when brushed on too thickly because they form a film on the surface and begin to stain the white clay. These media, when thinned, can be airbrushed effectively onto the scratchboard surface. Other suggestions and examples of working with color in scratchboard and with experimental surfaces, tools, and painting media are discussed later. It is best to first learn the basics of the traditional technique and medium.

*The best inks to use for applying black surfaces or lines on white scratchboard are Technical pen ink, India ink, and black Sumi ink.*

## PREPARING THE BOARDS

Let's begin by preparing white scratchboard for drawing and scratching. Although the plain white surface can be used without any additional preparation, it is wise to use the following technique. Erase the surface vigorously in two perpendicular directions with a Faber-Castell Pink Pearl eraser or a plastic eraser. Then, with a tissue or cotton ball saturated with a 70 percent rubbing alcohol solution, wipe the surface lightly and let it dry. These two steps will further enhance the polished enamellike sheen, lessen the likelihood of the clay clogging your pen once you start to draw, and simultaneously remove minor surface blemishes. Since the alcohol will smear ink, you must prepare the surface before you start any drawing.

To create an area or line in black, start by using the India ink or another black waterproof ink. For areas where you will want only black lines or lines with little scratching through, a fine sable brush works wonderfully. You may also find useful a dip pen, such as a Crowquill, Gillott's lithographic pen (perhaps #290 or #291) for fine work, other calligraphy pens (such as those with spoonbill nibs), or even a technical pen (such as Rotring Rapidograph, Koh-I-Noor, or Faber-Castell). To cover large areas, you should use a brush. A sable watercolor brush is the most desirable and controllable and offers the widest range of lines. But it is also the most expensive brush. The comparatively cheaper Japanese badger brushes and synthetic sable or squirrel hair bristle brushes are perfectly adequate.

In cases where even larger areas are to be covered, a soft, wide flat brush or foam brush from the hardware store works well. Since ink tends to make bristles dry and brittle after a while, take care to wash the brushes with a mild soap and warm water after use. Make sure you attend to the area where the bristles meet the handle, an area where many bristles will snap off.

It is also extremely important to keep your drawing surface clean. Keep a drafting brush handy to dust off the clay as you work. Be careful not to work in front of a fan or open window with a breeze, since it is quite easy to inhale clay dust. Although the chemical makeup of the clay and India ink is inert and neutral, breathing in large amounts of the dust might be irritating to some artists and in any case cannot be too healthy. It might even be wise to wear a mask that filters out the particles. But since I find myself always needing to lightly blow off the dust to see what I'm doing on the illustration, a mask can get in the way. Another problem is that the clay dust can clog your pen and change the ink's consistency. To remove any clay buildup, wipe your pen tip often with a paper towel.

Undiluted ink applied to the scratchboard thinly and quickly works most effectively. Be sure to mix the ink thoroughly. Some artists prefer two applications of slightly diluted ink to create a solid black surface. In either case, make certain that the amount of ink is applied consistently over the entire image area. If the ink is too thickly or unevenly applied, air bubbles or thick-inked areas will occur that will then crack when dried, causing the surface to respond differently to the scratch. On the other hand, if the ink surface is too thin or is mottled or transparent, you will not get a consistent color of black, and your system to achieve value and tone will become confused and undependable. Remember that this illustration will be reproduced as a line shot—all the blacks *must be* 100 percent and solid. There will be no Benday dot screens as used in reproducing ink wash drawings. Keep the brush saturated with ink but not so full that it drips off the bristles. Lay down a small area in short strokes that do not overlap. Avoid going over an area in strokes of different direction, since the ink tends to build up very quickly and will be difficult to scratch into. If the surface is mottled, wait until it is totally dry before touching it up, then do so quite sparingly. Make sure you are

not using a transparent ink or dye or an ink that is not well mixed. These inks will be absorbed quickly into the chalk surface and will stain the chalk all the way down to the baseboard. You will never be able to scratch through to get a white line.

An airbrush is excellent for laying down a smooth opaque surface. It is also helpful to cut a mask with frisket film to protect the areas that will remain white or primarily white. Waterproof drawing ink and airbrush is perhaps ideal for laying in large areas of black.

Once you have the black ink laid down, wait at least fifteen to thirty minutes until it is absolutely dry before attempting to scratch through. If the surface is still damp, cut lines will be ragged and thick, and your cutting tool will pick up some of the surrounding wet-inked chalk surface.

*The board should be taped down on the drafting table across all four corners and the image area outlined in nonreproducible blue pencil. Any horizontal or vertical lines should be done when the board is taped down. The board need not be taped down for other freehand drawing and scratching. India ink should be laid down thinly and consistently with a flat brush. One opaque application should be enough.*

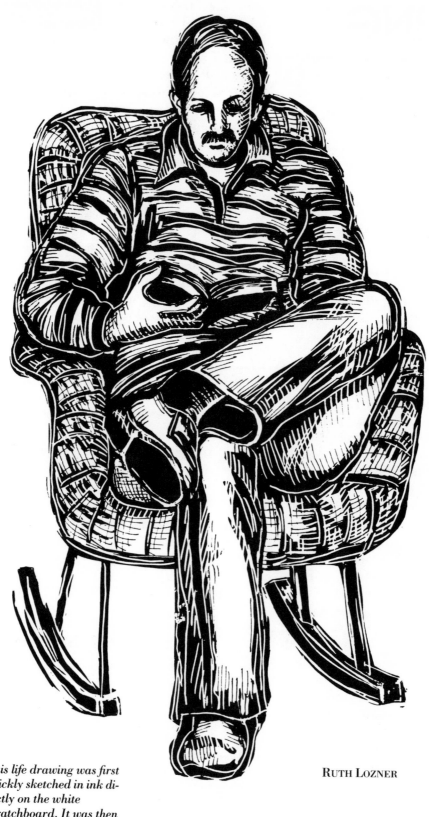

*This life drawing was first quickly sketched in ink directly on the white scratchboard. It was then further manipulated with a scratchboard tool.*

RUTH LOZNER

# GETTING ACQUAINTED

Before experimenting with specific techniques, it is advisable to have a feel for the medium and the tools. The goal is to acquire a sufficient vocabulary to express your point of view and to develop basic skills that will allow you to draw in any technique. Learned techniques will facilitate and promote your artistic expression so that your style will become as unique and distinctive as your handwriting.

Start warming up by doodling and sketching with the tools and ink. Use small pieces of scratchboard, perhaps no larger than 8″ × 10″. Play with the tools you have at hand. See what effects you can obtain by varying the pressure and speed with which you work. When using white scratchboard, practice application of the ink with brush and pen until you can achieve a consistent solid black that is thin and opaque. Establish a repertoire of straight lines and curved lines drawn with both even and uneven pressure. Work with marks, dots and dashes, scratchy/sketchy, wavy, and erratic lines. Try expressive, animated lines, drawn and cut using different degrees of energy and speed.

*Warm up by becoming familiar with the ink and scratchboard tools on both white and black scratchboards.*

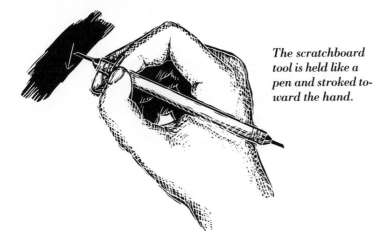

*The scratchboard tool is held like a pen and stroked toward the hand.*

## BEGINNING A DRAWING

Begin your experimentation with several exercises that address the issue of value, or tonality. These exercises will familiarize you with the ways to achieve this quality through line and marks. Try copying some of the examples illustrated here. Then create your own examples of marks and lines that reflect your personal style.

When lines vary in proximity, width, and intervals, a variety of values will occur. At a distance, the eye will merge these lines and accept them as a tonal area. The thinner the black lines (or thicker white scratches) and the greater the space between them, the lighter the value or tone, and, conversely, thick black lines placed closely together create a darker value. Similarly, with smaller marks—the closer the black marks are to each other, the darker the value. The more white scratched marks or more white of the board showing, the lighter the value you will achieve. You should now have a better idea of how to achieve a logical system of tone/value.

Refer to examples of the techniques on the following four pages for achieving texture and value. In a black-and-white linear technique such as scratchboard, the difference between texture and value is relative. *Value* is the proportion and amount of white cut into black or vice versa, and *texture* derives from the manner in which the white and black are drawn or cut. *Form* is conveyed through light and shadow and the direction of the scratched and drawn lines. Use these exercises as references, and proceed to more elaborate drawings.

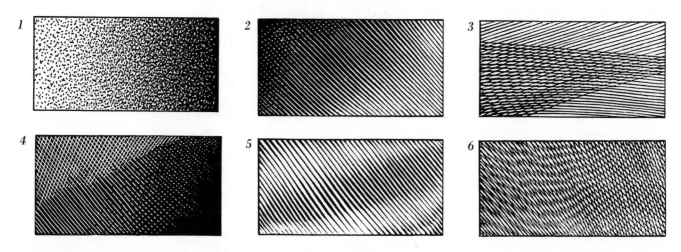

*(1) Stippling with ink and scratches; (2) modulated ink lines and scratches; (3) crosshatching with inked lines; (4) crosshatching with scratched lines; (5) modulated ink lines; (6) crosshatching with lines at different angles to create a moiré effect.*

*These lines were made with the Scratcher, a multiline tool.*

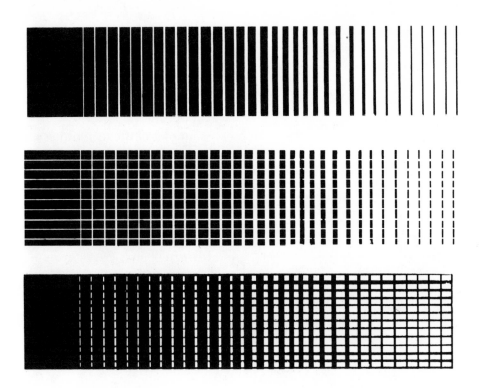

Shown at left is a value scale that gradually blends black into white by beginning with thin scratched lines in the black and ending with thin inked lines in the white. The width of the intervals gradually changes to create a range of grays from dark to light. With the addition of scratched lines (middle drawing), the values will lighten. With the addition of black inked lines (bottom drawing), the values will darken.

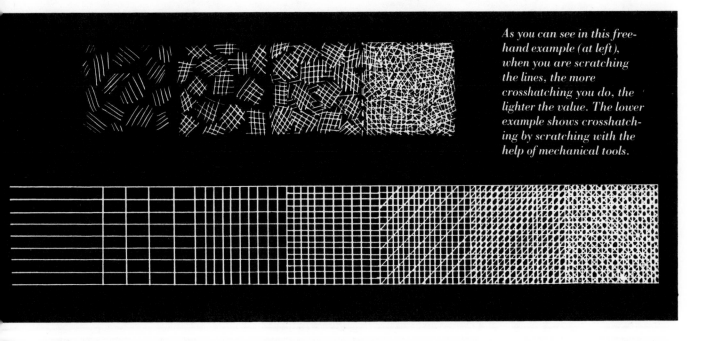

As you can see in this freehand example (at left), when you are scratching the lines, the more crosshatching you do, the lighter the value. The lower example shows crosshatching by scratching with the help of mechanical tools.

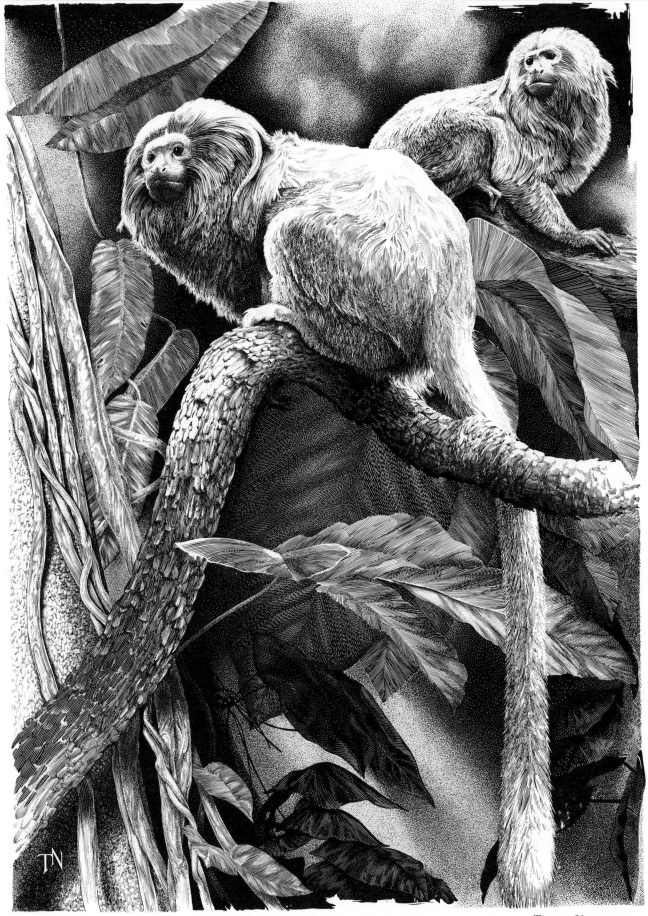

TRUDY NICHOLSON

In this exquisitely accomplished example, the artist employs all of the basic line and mark techniques as discussed earlier in this chapter to render value, light, and shadow volume and texture. These enlarged details illustrate the application of the techniques. The overall look is one of an intricate wood engraving.

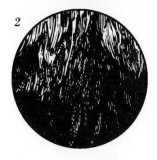

*1*

*Stipple in ink*

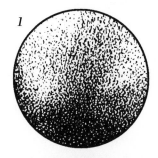

*2*

*A combination of inked and scratched lines ending in dots and dashes creates a seamless transition between techniques*

*3*

*Black inked lines crosshatched with scratched lines*

*6*

*Stipple in scratches*

*4*

*Black inked lines crosshatched with inked lines*

*7*

*Black modulated inked lines*

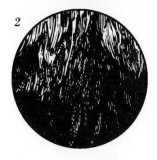

*5*

*Black inked lines crosshatched at different angles with inked lines for a moiré effect*

*8*

*White scratched lines*

# UNPLANNED DRAWING

There are essentially two kinds of drawing—*unplanned*, which is sketched directly on the scratchboard in freehand, and *planned*, which is carefully predrawn and then transferred to the scratchboard.

Let's begin with a simple freehand drawing, one without elaborate texture or pattern. As with pen and ink drawing, you can begin drawing in pen or brush directly onto the white scratchboard surface. Note that I have suggested that your initial drawing be on the white not the black preinked scratchboard. It will feel more familiar to you since it seems closer in approach to traditional pen and ink drawing. A brush works best at this stage, since many pens may clog before you get the right feel of the tool. If you do desire to work with a pen, a dip pen with a spoonbill nib is a good one to start with. The spoonbill nib slides over the surface and will not dig into it. Begin by drawing a simple still life of one or two objects.

Value or tone is the relative amount of light or dark in a given area. A lightly colored object must be contrasted with a darker background or object to show its relative "color," or value. Observation and analysis of the light and shadow areas require thought. Think through a logical method to suggest the appearance of values. Start seeing objects in their surroundings in terms of relative "color," tone, and value.

Simplify the object into high contrast of dark and light. Ink in the outline or silhouette or the large masses of dark. Later, you will incorporate values and tones with the scratching of the white lines in the black areas and drawing into the white areas with black ink. Be as accurate with the silhouette or outline as possible. This will prevent needless scraping away of large inked areas when you are completing the illustration. Block in the composition quickly. Within the silhouettes where scratching will be done, ink in irregular shapes. This will help mask the delineation between inked and scratched areas. Ink those areas that will be 50 percent black or more.

The highlights of an object are those areas that protrude and are closest to the light source or those areas that reflect light. Dark values include those areas farthest from the light source and in shadow. The middle areas, the "areas of gray," are the black areas into which you will scratch, revealing white lines or areas of white board on which you will use inked line with brush or pen.

Now start drawing directly on the board in ink. Be sure to allow for plenty of white space around your drawing. This will come in handy if you modify your composition by adding or subtracting some of the image. It is also useful when an illustration is photographed for reproduction, and it further protects the drawing from damage if the board is dropped and injured.

You will be drawing in a positive manner: Your black marks will be the figure component on a white ground. You can then pull out the highlights (that have not been left white), middle values, and the details by scratching into the black areas. If you scratch a line that you later decide you don't want, simply ink over it. If you have drawn an area or line in ink you do not want, lightly scrape it off. The pressure of the mark and the grade of the board will determine how many times you can manipulate the surface. Avoid overworking. From these initial trials, go on to the next drawing quickly and learn from your attempts rather than belabor an issue. At this stage, enjoy the process and get to know the medium.

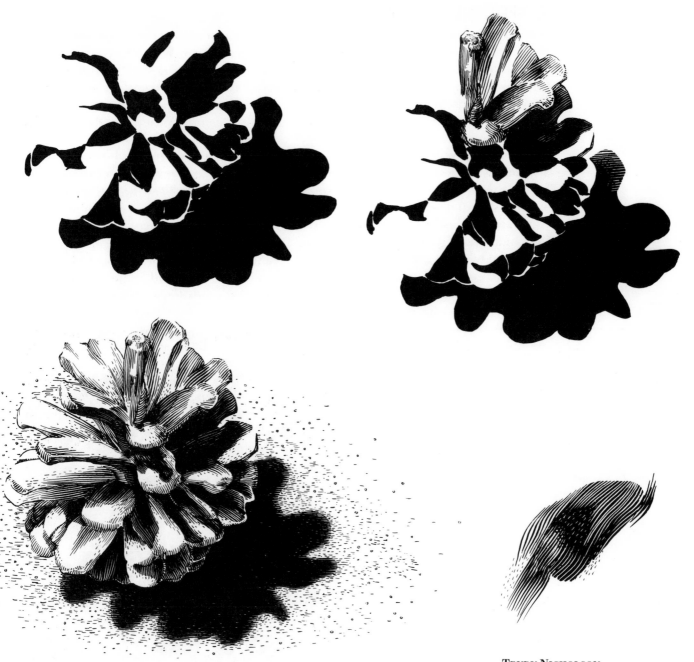

TRUDY NICHOLSON

*The large areas of dark value and shadow were first blocked in with ink. Then the intermediate values were inked in with fine brush lines and scratched out with the scratchboard tool. The attenuated lines end in dots and dashes. The finished drawing was rendered in full value. Note the enlarged example of the line techniques.*

# PLANNED DRAWING

Now let's try a planned drawing. Most of the illustrations used throughout this book have been very carefully planned. Commonly, illustrators use preparatory stages of thumbnails, roughs, and comprehensives that lead up to the finished illustration.

Brainstorming and free-associating in a sketching stage will help you arrive at a basic concept and approach, with minimal investment of time or expense. Once you have established your idea in the thumbnail stage, go on to the rough stage, where you begin to work out the drawing issues and composition and to refine the concept. This stage should be executed in the same size as the final product or in proportion to it. When the roughs are the same size as the desired finished piece, the drawing can be transferred onto tracing or opaque paper for the comprehensive, or "comp." Most of the drawing and conceptual issues should be resolved in the rough stage. In the comprehensive stage, there is a resolution of the values, and the drawing can be tightened to a more finished state. You can do the more refined comprehensive stage in any medium—marker, ink, felt-tip pen, pencil. To work out the values for scratchboard, you might also find it helpful to do a charcoal rendering or ink wash drawing.

*This planned drawing began with an initial thumbnail sketch.*

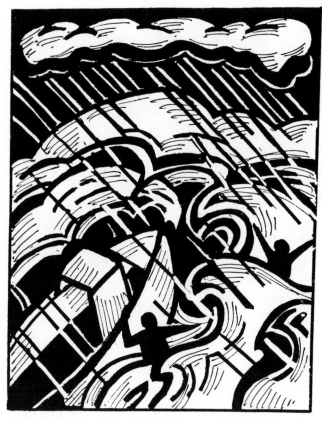

*A comprehensive drawing, done in pen and ink, worked out more of the image.*

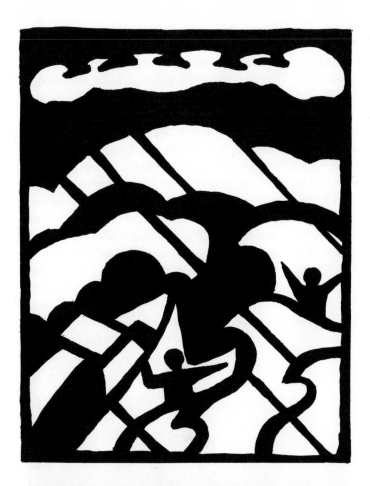

*After the basic drawing was transferred onto the scratchboard, the major black and dark value areas were loosely blocked in with ink and brush.*

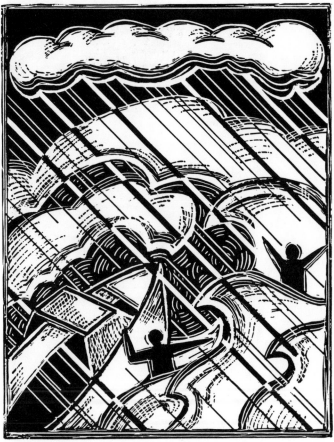

*The finished illustration was rendered with inked and scratched lines and marks.*

RUTH LOZNER

## TRANSFERRING THE DRAWING

There are several ways to transfer your drawing onto the scratchboard itself. The easiest way to transfer the comprehensive drawing onto the scratchboard is to use a piece of prepared graphite paper, such as Saral paper, which is also available in yellow, blue, and red. You can also use tracing paper, rubbed on the back with a soft 4B or 6B graphite stick. A nonreproducible blue pencil or yellow pencil rubbed on the back of the tracing paper is equally effective. Even carbon paper from the stationery store will work well on black scratchboard. You can see the waxy black from the carbon paper when your drafting lamp is placed at an angle and the lines will not rub off as you work.

If the drawing is simple, you might not want to blacken the entire surface. Instead, you can retrace only the major lines on the back with a soft pencil. If you have used opaque paper for the comprehensive, retrace the important lines onto thinner tracing paper. The tracing paper allows you to position the drawing properly on top of the scratchboard. If you are using the prepared graphite paper, place it facedown between the drawing and the scratchboard surface. If you prepared your own transfer surface on the back of the comprehensive, make sure the original drawing is faceup and taped onto the scratchboard. With a ballpoint pen or a dull pencil of another color, carefully redraw the significant lines and details in the drawing. Do not press too

*The comprehensive drawing on tracing paper was done in pencil.*

*The transferred drawing as it appears on the scratchboard.*

hard when transferring the drawing, since it is not necessary to indent the scratchboard. A carbon imprint will be left on the scratchboard. Save all your preliminary drawings—most especially the comprehensive—for reference as you start working on the actual illustration.

If you are using a lighter-weight scratchboard, a light table with strong lights can be adequate. Place your ink drawing between the light table and the

scratchboard and redraw directly onto the board. Certainly you can do some of your drawing directly on the scratchboard using a harder HB or 2H pencil.

Remove your transfer tracing paper and begin to ink in the drawing on the scratchboard. You might start with the solid black shapes and move into the more linear areas. After you have finished the inking, you may find that you have to use a kneaded eraser to remove some of the remaining graphite lines. Be very careful not to lift up too much of the ink. If you have created a mottled black area by erasing too hard, retouch very judiciously now. Let the ink dry thoroughly. Now you can scratch back into the drawing to reveal the highlights, middle tones, and details.

*The comprehensive drawing is positioned and taped over the scratchboard.*

*With graphite paper facedown between the drawing and the scratchboard, the essential lines are retraced with a ballpoint pen.*

*The drawing is inked in on the scratchboard.*

*The finished drawing is ready for further work with scratchboard tools, pen and ink, and brush.*

# USING PHOTOGRAPHIC REFERENCE

Illustrators must sometimes rely on photographic materials for referencing authentic details and images. It is always helpful to take your own photographs. When this is not possible, the artist must use preexisting photographs or reference materials supplied by the client or found in the library.

For a number of reasons, too heavy reliance on any photographs, especially those taken by someone else, can be artistically limiting. First, there is a great temptation to adjust one's idea to what is readily available rather than to create a photograph to suit your own concept and composition. Second, a preexisting photograph is someone else's interpretation and vision of reality (and a generation removed at that) and not your own.

Third, a drawing that is a meticulous copy of a photograph may lack imagination, spontaneity, and dynamism.

Successfully capturing in scratchboard the dramatic contrast of light and shadow and minute detail, which is found in photographs, represents a real technical challenge. The beauty and uniqueness of an original work of art is, however, inherent in the special qualities of the chosen medium and in the clearly individual mark of the artist's hand and mind. Use photographs for inspiration and information, but allow the unique characteristics of scratchboard to show through.

With that caution stated, I can go on to mention the special value of taking your own photographs for reference. Not only can you shoot the specific details needed to supplement your overall composition, but you can also set up one strong light source to enable you to see the high contrast of values of the subject to facilitate rendering it in scratchboard.

*A Polaroid photograph was used as a reference for the figure, and a photocopy enlargement of the Polaroid aided in bringing out the values in black and white. The figure was placed in an environment appropriate to the assignment.*

RUTH LOZNER

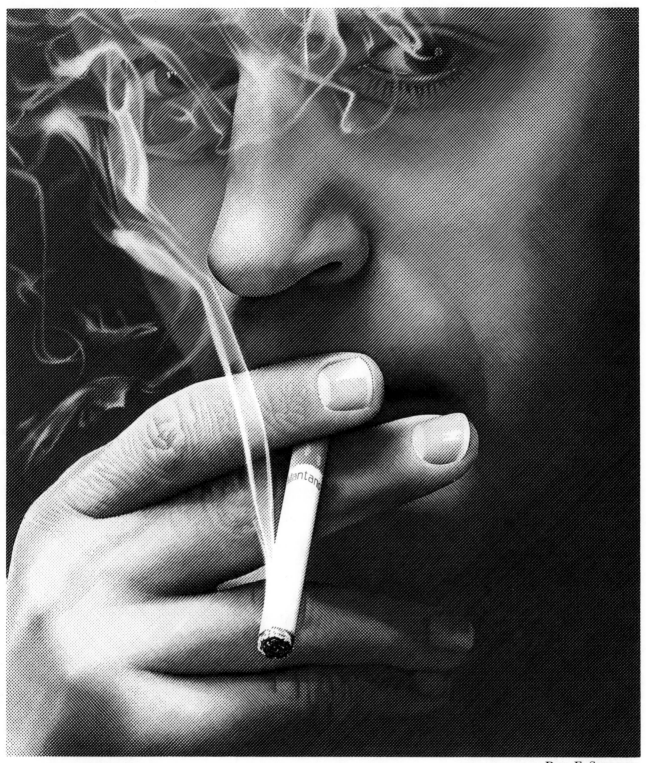

PAUL E. SHELDON

*Far more revealing than a photograph, this remarkable example pushed the limits of the medium by using an intricate technique employing technical pen and scratched lines.*

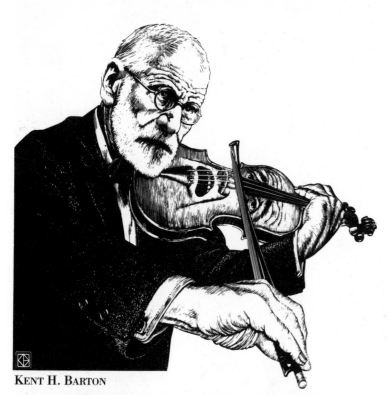

KENT H. BARTON

Frequently, a Polaroid photograph will be adequate. Sometimes it will be necessary to have enlarged or photocopied prints in black and white or color for observation and study. Aspects of the photograph can be directly traced onto tracing paper or lightweight drawing paper or scratchboard with the use of a light table. You can also use a camera lucida or opaque projector, which can reduce or enlarge the photographic image.

Some artists prefer slides and use the projected image as reference. With this method, you can then trace the projected image onto a piece of paper that has been taped onto a wall in a darkened room. Rarely can the whole original photograph be used. More often, certain sections of many photographs may have to be combined to provide you with a successful composite.

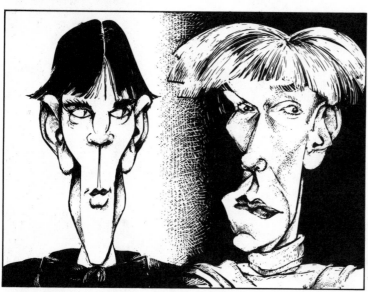

JOHN MANDERS

*In these three illustrations—Sigmund Freud (top), Aubrey Beardsley and Andy Warhol (above), and William Faulkner (above right)—the artists had to use photographic reference to ensure authenticity. This is true in portraiture, no matter how interpretive.*

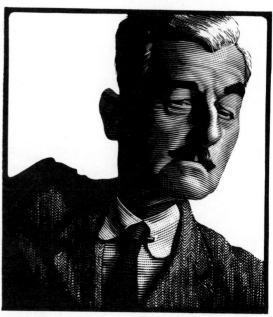

MARK D. SUMMERS

# CORRECTIONS

A line or area that has been mistakenly cut or scratched is the easiest to correct: Simply brush ink over that area. An area that is mistakenly black can be scratched away. After you have laid in the whole composition and tonal system, values that appear too dark can be hatched or crosshatched with white scratches. Areas that are too light can be hatched or crosshatched with black ink lines. Large areas of black surface can be removed carefully with the broad side of a scratchboard blade, a single-edged razor blade, or fine sandpaper. Remove only the thinnest possible layer, and use the plastic eraser to repolish the surface. With the higher-grade scratchboard, you may be able to reink and recut a few times.

It is always easier to apply the ink accurately and scratch to white carefully than it is to attempt too many or too radical corrections. Also, never scratch into the scratchboard too deeply. This will make reinking and recutting difficult. In dire situations, when you need to completely redraw a large area, carefully and precisely glue a patch of thinner scratchboard onto the original scratchboard, where you can then redraw the "mistake." Another way is to make a collage of a photostat of the illustration combined with another photostat of a more satisfactory section to produce a whole successful illustration.

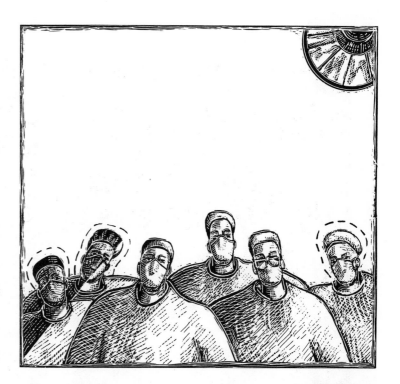

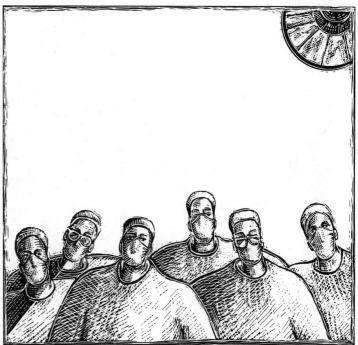

RUTH LOZNER

*Most of the original drawing was successful. The three unsatisfactory heads were replaced. The new drawings were done on thinner scratchboard, then cut and collaged onto the original board.*

JEAN TUTTLE

*The precisely executed sketch was transferred onto white scratchboard and inked in. The artist used mechanical pens, rulers, templates, and French curves to refine the edges to razor sharpness. The crisp and clean image emphasizes the design of the drawing.*

# MECHANICAL LINE TECHNIQUES

It is sometimes necessary to employ mechanical tools in order to achieve more controlled effects. Specifically, the technical drawing of objects that are man-made, such as commercial products and typography, or the rendering of extremely smooth surfaces, such as glass and metal, require a precise outline and depiction of shape, volume, texture, reflection, and tone. Mechanical techniques should be adapted to suit the image. The intended effect and the subject will suggest the technique needed. These technical tools are most often used with the positive pen and ink black line, but they can also be used in the exact same way for the negative scratched white line.

Needless to say, straightedges, such as rulers, T squares, or drafting-table parallel bars, will help produce absolutely straight parallel horizontal lines. Although very difficult to find, a drafting device called a haff, consisting of a ruler fixed horizontally to a mechanism that measures intervals between lines, is extremely helpful. Once set, the ruler will automatically drop down a predetermined distance when triggered. Parallel lines can be cut or inked with precision and ease. Other drafting machines that attach to the drafting table, such ones made by Mutoh and Alvin, have incremented measuring devices for speed and efficiency in producing straight parallel, horizontal, diagonal, and vertical lines. Triangles in combination with regular T squares help with vertical and diagonal lines. It is advisable to use *metal* rulers, straightedges, and triangles. Plastic ones are easily nicked by some of the sharp scratchboard tools and can be ruined for further reliable use.

A complete set of French curves are handy for achieving all types of curves and arcs. A set of draftsman templates for ellipses, ovals, or circles are also im-portant, but they are difficult to use with certain scratchboard tools. The most expeditious way to cut a perfect circle is with a compass. Simply substitute the pen or pencil insert of the compass with a sharply pointed nib or scratchboard blade. With the blade adjusted to the proper position, you can etch a circle or arc in the same way as you would draw it with ink or pencil. You may also want to cut your own template of a particular arc or wave out of heavyweight acetate or board and use it as a guide for inked or scratched lines.

These tools are necessary for accuracy and authenticity. By their nature they can give your work a tighter, more controlled look. Plan your drawings very carefully in the comprehensive stage. Be certain that the perspective, light and shadow, value, and details are clearly and precisely worked out before transferring the drawing onto the scratchboard.

*Aids such as circle and ellipse templates and French curves can help the artist render curvilinear lines with tight control.*

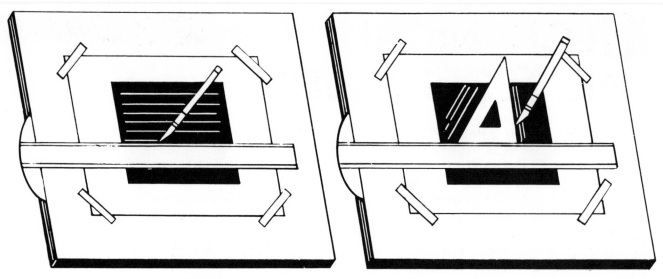

*Using a T square on the drafting table will help you with parallel horizontal lines.*

*A triangle laid on the T square will help you with parallel verticals and 30°, 45°, and 60° angles.*

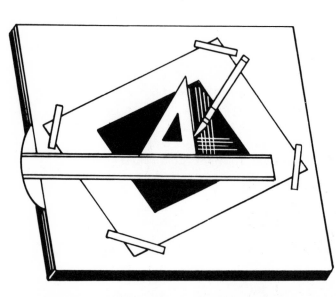

*Other parallel diagonals can be achieved by taping the scratchboard at an angle on the drafting table. An adjustable triangle can also be used.*

*To incise larger circles, you can use a compass with a blade attachment or dividers.*

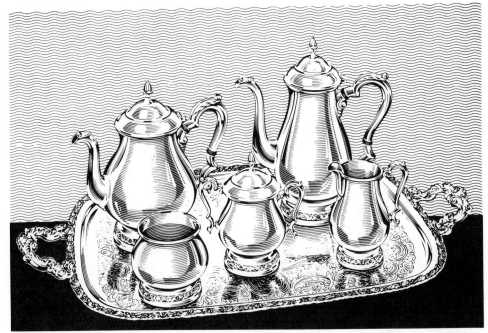

*Scratchboard illustrations of products, especially those used in newspaper advertisements, reduce and reproduce immensely better than halftone photographs. The nature and materials of the products necessitate precision of line and exactness of tone. A thick and thin brush line, as well as scratched lines, are drawn with the help of templates. The background behind the silver tea set is a preprinted screen.*

Bodhan Osyczka

Bodhan Osyczka

RENÉ ZAMIC

VIRGINIA PECK

*Both of these drawings rely in part on parallel and measured lines and scratches for tonal effects. Some of these lines were drawn freehand; others were drawn using mechanical aids.*

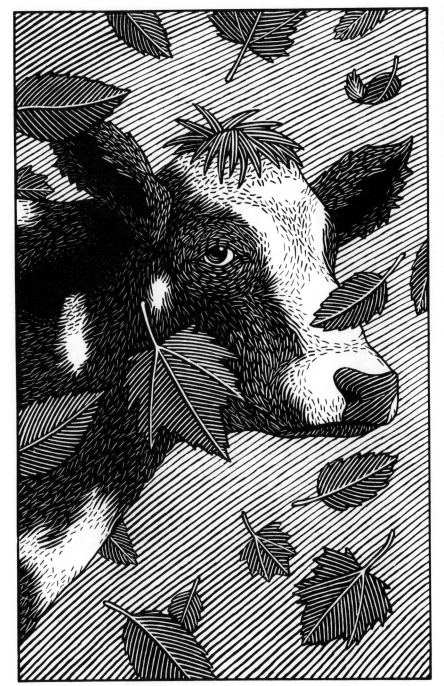

DENNIS STANHOPE

*This artist used a direct translation from a thumbnail sketch to the board. The inked drawing was then refined using a variety of mechanical aids to achieve a deliberate and exact result.*

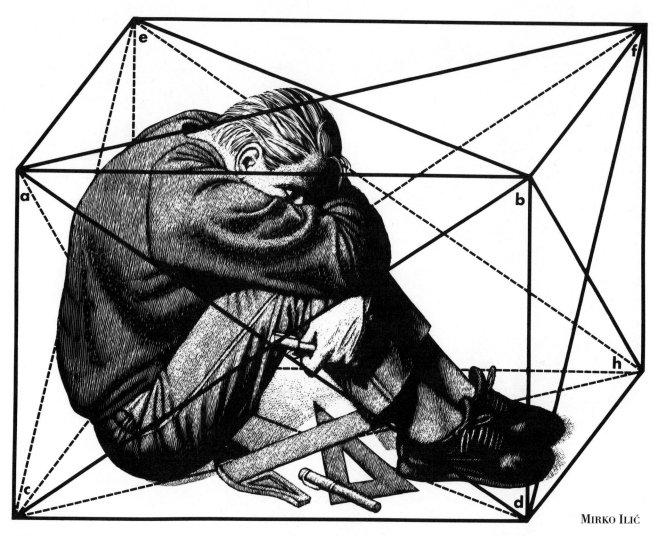

MIRKO ILIĆ

*A freehand drawing can be combined
with mechanical elements. Black tape
and press-on letters, for example, can
be superimposed over the completed
scratchboard drawing.*

PAUL E. SHELDON

*The rendering of reflective surfaces, such as glass, calls for extreme control of the medium.*

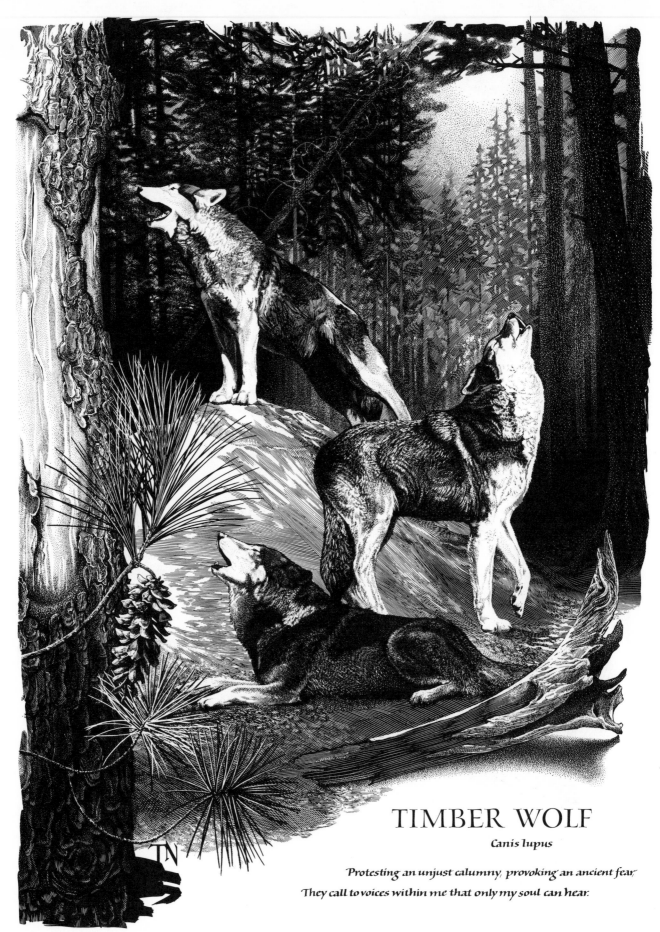

# TIMBER WOLF

*Canis lupus*

*Protesting an unjust calumny, provoking an ancient fear,*
*They call to voices within me that only my soul can hear.*

TRUDY NICHOLSON

By Trudy Nicholson © 1987

46   SCRATCHBOARD FOR ILLUSTRATION

# FREEHAND LINE TECHNIQUES

Freehand line techniques are analagous to calligraphy. Lines can be free-flowing or controlled in both the inking and the scratching. The following illustrations are examples of some freehand line techniques. There can be as many and varied possibilities as those in handwriting. Some lines work better than others to indicate texture, pattern, or value. Some line techniques combine well with others, while others seem incompatible. I have extracted sections of some of the illustrations to focus on certain line styles. Combining these simple line approaches can yield unique linear effects, as you will discover when you experiment.

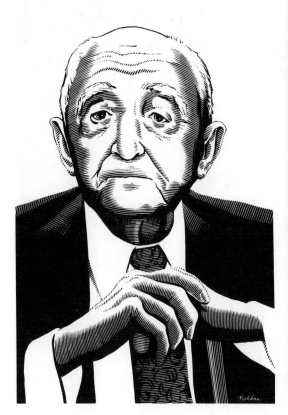

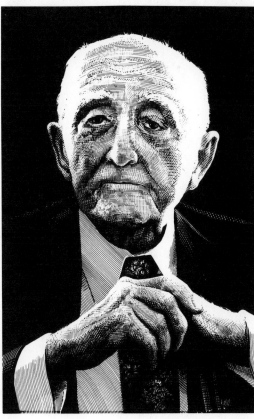

*With the same drawing used as a reference, the first portrait was rendered with modulated lines and scratches, and the second with lines that are crosshatched with ink and scratches.*

BOHDAN OSYCZKA

*The artist used a wide variety of intricate lines and marks to create this precisely rendered illustration.*

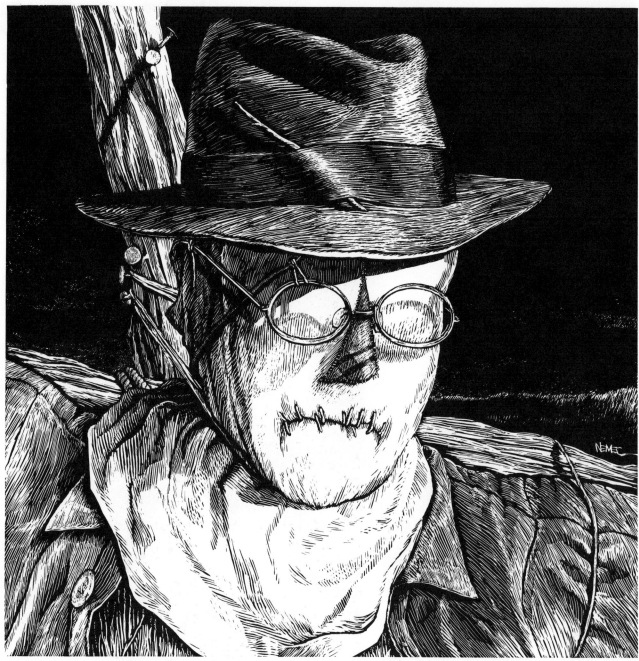

GREGORY NEMEC

*A complete pencil drawing was done directly on white scratchboard. The interplay of white on black and black on white creates an ambiguity between the techniques of inking and scratching.*

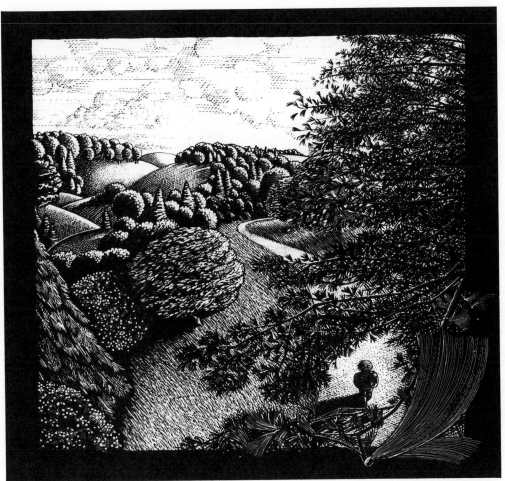

Different textures, surfaces, and planes are described with different lines and marks. For example, the open system in the sky of parallel lines crossed with scratches in contrast to the more densely hatched marks on the ground.

LIISA RITTER

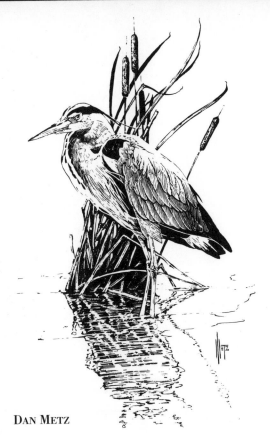

The subject was outlined and simply inked and scratched with hatch marks, the lines flowing with the form. The scratchboard tool was pushed and not pulled downward in order to create the irregular strokes in the water and reeds.

DAN METZ

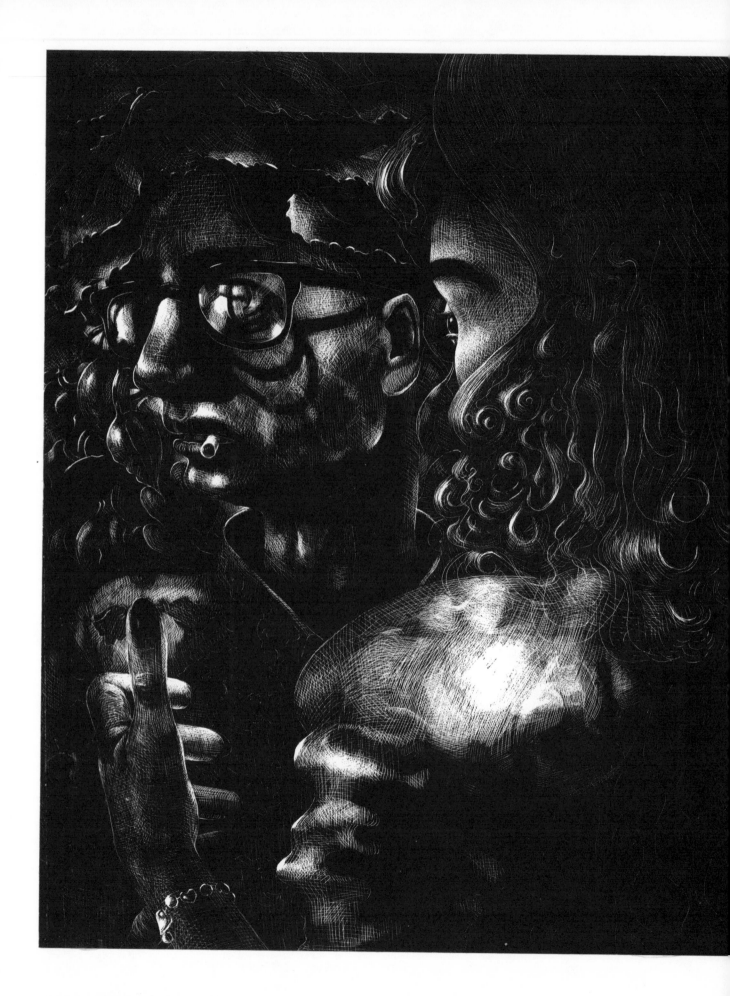

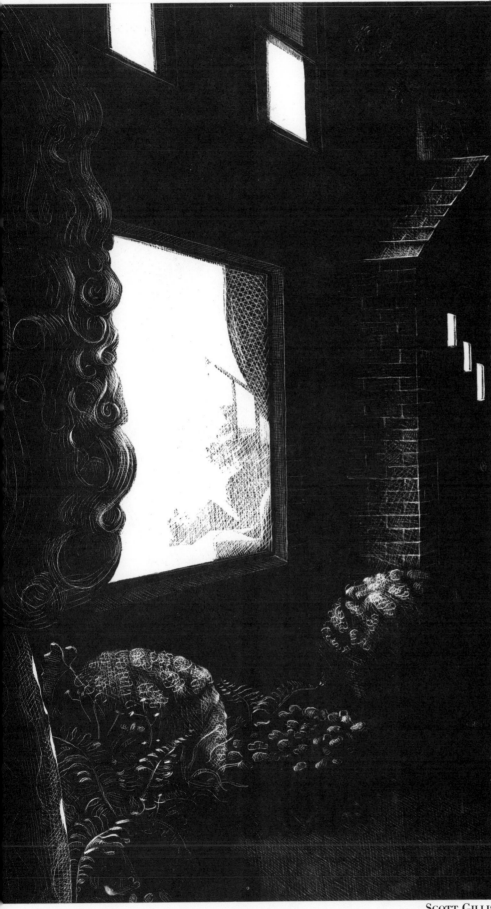

*Fine crosshatching scratches in black scratchboard reveal light, form, and detail.*

SCOTT GILLIS

*This illustration was rendered with an open system of curved and straight parallel lines.*

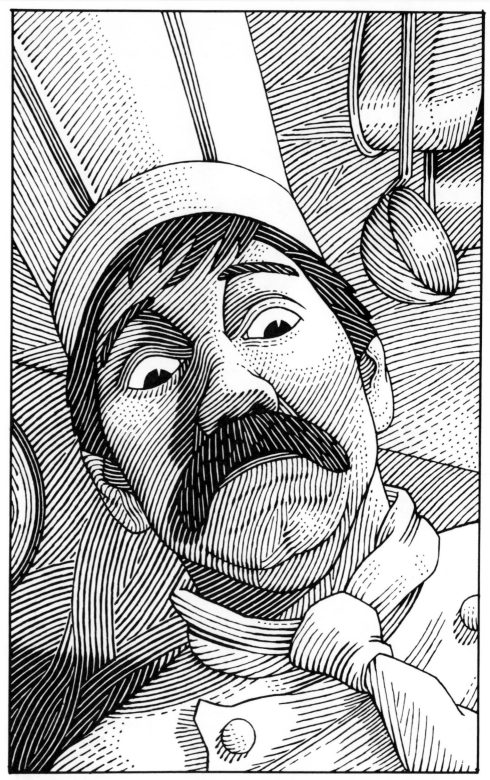

DENNIS STANHOPE

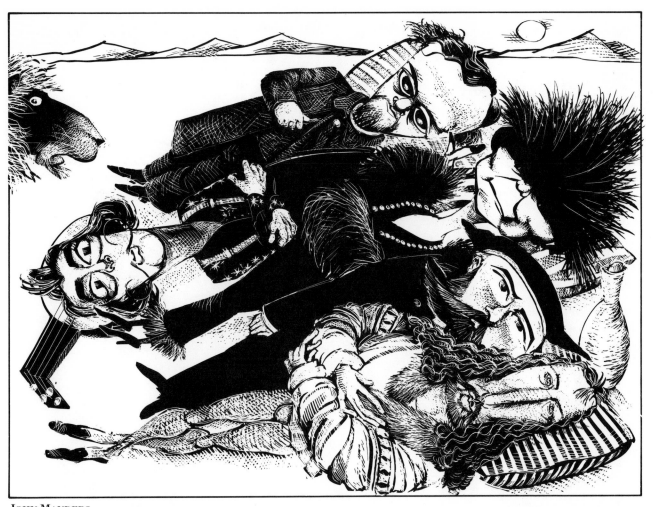

JOHN MANDERS

*This artist used a playful and free technique of working back and forth into the white areas with ink and the black areas with scratches. He depicts Dante Gabriel Rossetti, Salvadore Dali, Mary Cassatt, Henri Rousseau, with Albrecht Durer relaxing as Rousseau's Sleeping Gypsy.*

*This artist's own natural heavy-handed approach to drawing was pushed further by extensive use of thick black lines. He used "careless abandon" to put down the ink with a brush, then scratched away everything that he didn't want by using a #16 X-Acto blade.*

ROBERT ZIMMERMAN

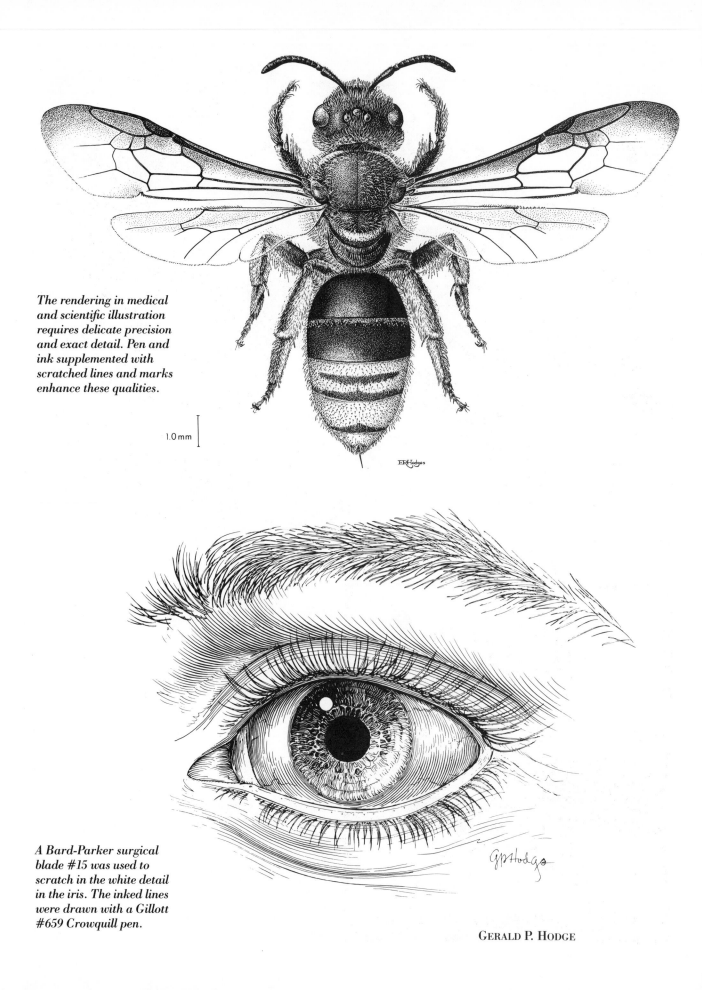

The rendering in medical and scientific illustration requires delicate precision and exact detail. Pen and ink supplemented with scratched lines and marks enhance these qualities.

1.0 mm

A Bard-Parker surgical blade #15 was used to scratch in the white detail in the iris. The inked lines were drawn with a Gillott #659 Crowquill pen.

GERALD P. HODGE

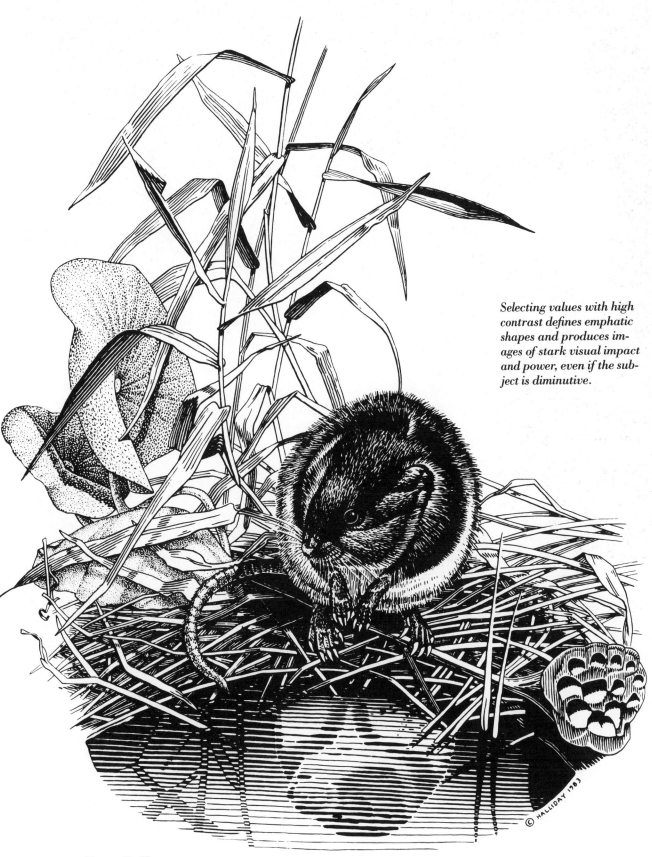

*Selecting values with high contrast defines emphatic shapes and produces images of stark visual impact and power, even if the subject is diminutive.*

Nancy R. Halliday

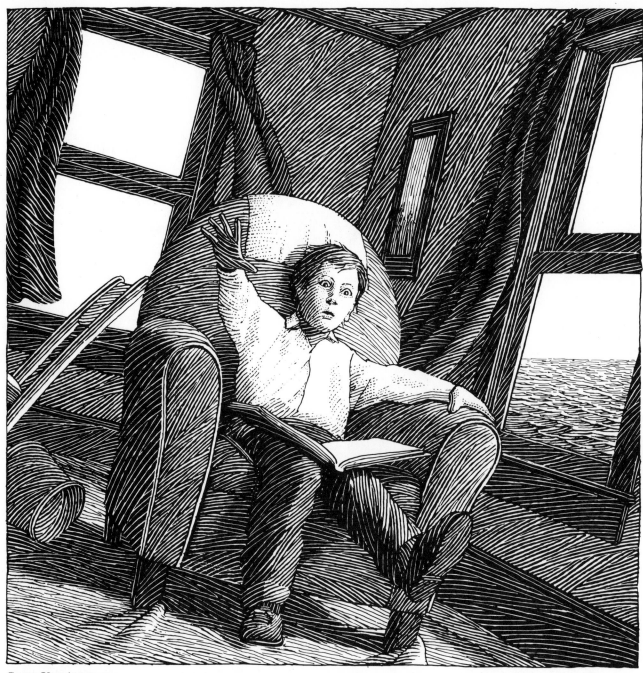

## CHRIS VAN ALLSBURG

From *Ben's Dream* by Chris Van Allsburg.
Copyright © 1982 by Chris Van Allsburg.
Reprinted by permission of Houghton Mifflin Company.

*Shapes, volumes, and tones
are defined by width and
direction of line in this
illustration.*

*Scratchboard added texture, depth, and volume to an otherwise flat drawing of comic strip art. Scratchboard panels were done separately and pasted onto traditional pen-and-ink drawings. Letratone films were also used.*

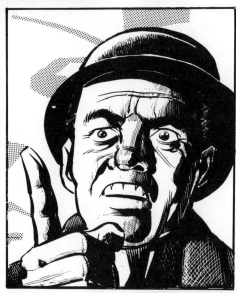

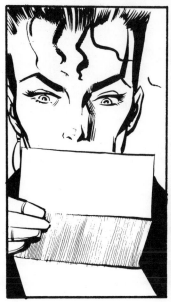

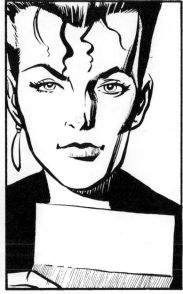

PETER MURPHEY

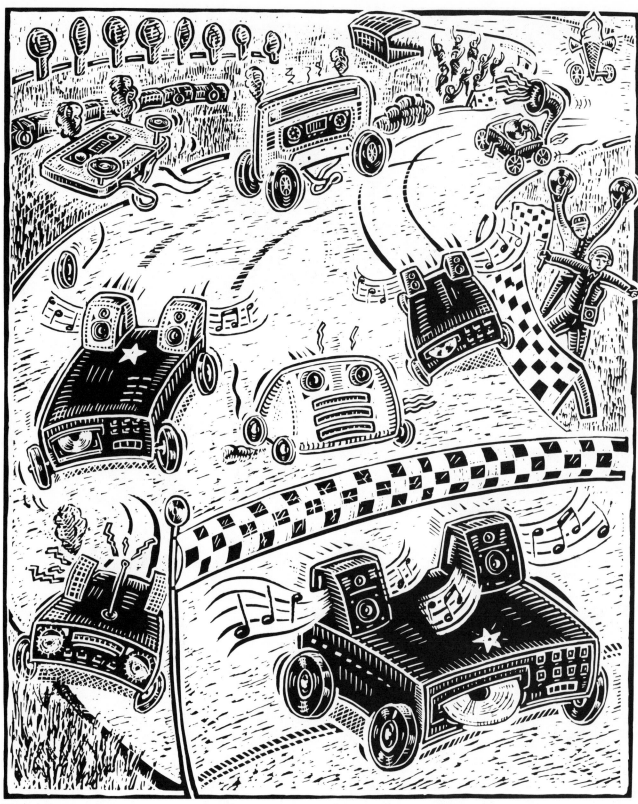

MICK ARMSON

*Short energetic lines are used throughout the composition to create the sense of activity and motion.*

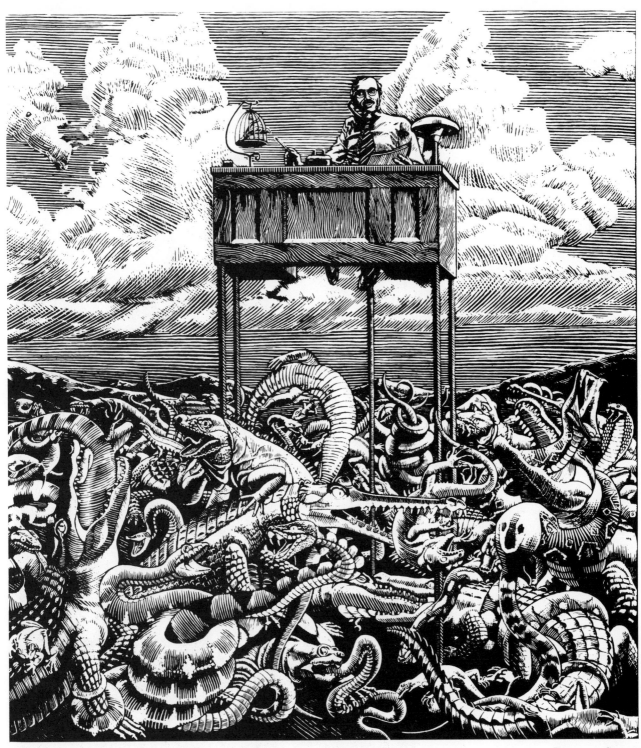

DOUGLAS SMITH

*The parallel horizontal lines in the sky and tightly rendered lines of the desk stabilize the upper portion of the composition. This enhances the sense of chaos that is densely rendered with undulating lines in the bottom half of the drawing.*

The playfulness of subject is reiterated
by the expressive and fluid decorative
marks used to render it.

BARBARA E. MURRAY

# PATTERNS, TEXTURES, AND MARKS

As in the case of line techniques, you can achieve patterns and textures in line and marks with or without mechanical tools. In the accompanying illustrations, the issues of pattern and texture are separated from those of tone and value. The difference between the techniques is the rel-ative use of line and marks. In other words, the marks used to describe a pat-tern on an object's surface are different from those used to bring out tone and value. Marks necessarily have to change to define the surfaces and textures of different objects.

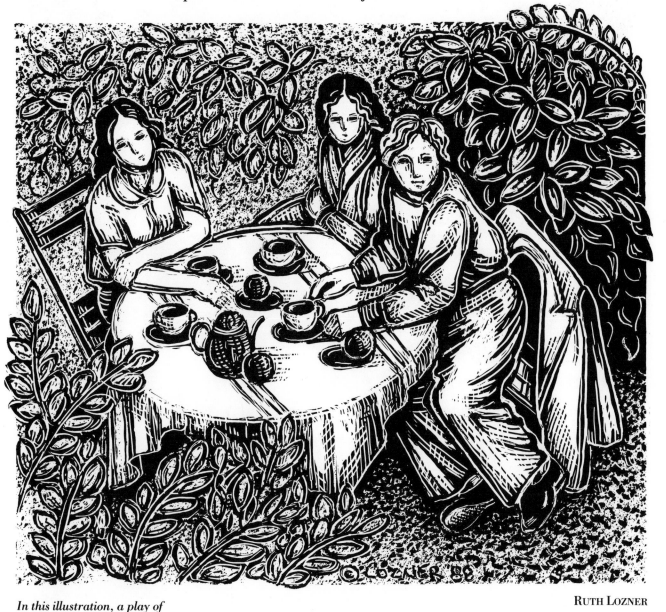

*In this illustration, a play of positive and negative lines appears in the pattern of the leaves. The background has been stippled with a toothbrush flicked with ink.*

RUTH LOZNER

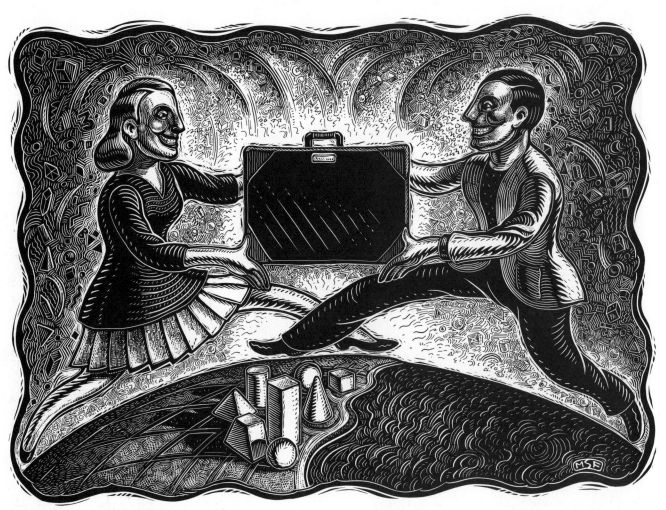

**MARY S. FLOCK**

*The versatility of the lines and marks describes rich patterns and textures in the background, and volumes and directions on the surfaces.*

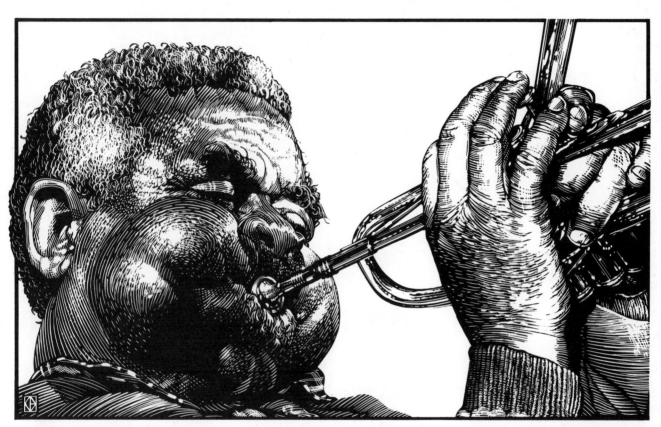

*In this portrait of Dizzy Gillespie, the artist used an assortment of lines and marks to follow the contours of the form and define different textures.*

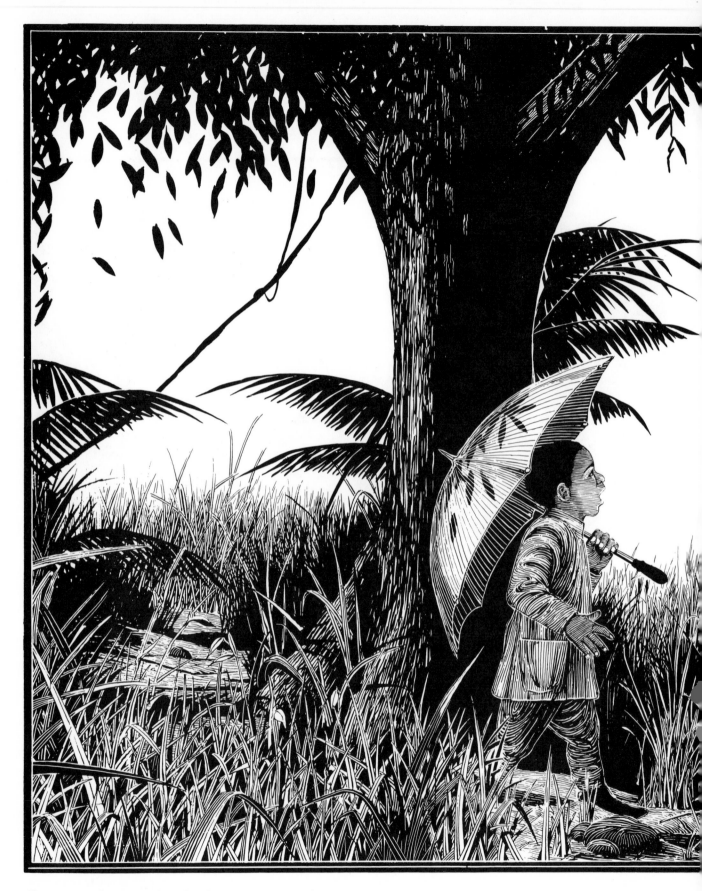

*By using a rich variety of marks, the artist can create the illusion of color in black and white.*

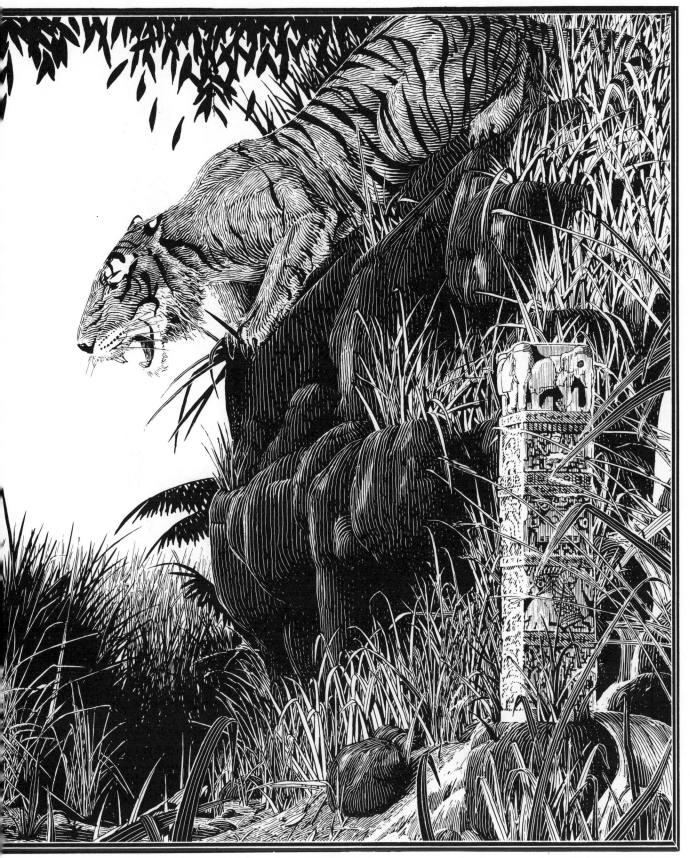

CHRISTOPHER BING

RUTH LOZNER

To achieve this drawing in woodblock, all of the white areas would have had to be cut away, leaving raised areas to be inked and printed. Using white scratchboard, ink was brushed on in specific areas and then manipulated with a scratchboard tool.

# Woodcut and Linoleum-cut Effects

Scratchboard is frequently used to give illustrations the look of a woodcut or linoleum-cut print. When mimicking the limitations and possibilities of the woodcut, the black-and-white lines tend to be larger, cruder, and less detailed. By greatly enlarging a small scratchboard drawing in reproduction, you can exploit and reinforce those characteristics by revealing the "unintentional" nicks left along lines or in the white areas to further create these effects.

*This illustration is similar in appearance to a Japanese woodblock. Its derivative subject matter is rendered with intricate pattern that is juxtaposed to solid white space.*

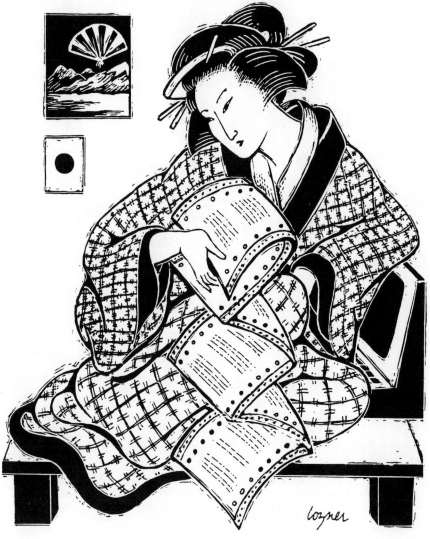

RUTH LOZNER

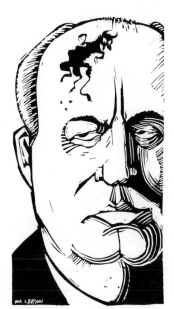

*Carving into the ink and squaring-off the lines leaves fine parallel "excess" marks, reminiscent of a woodcut.*

WILLIAM L. BROWN

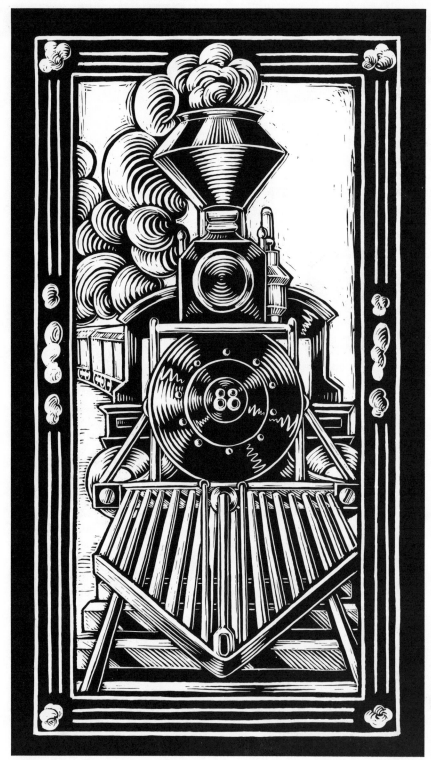

JENNIFER HEWITSON

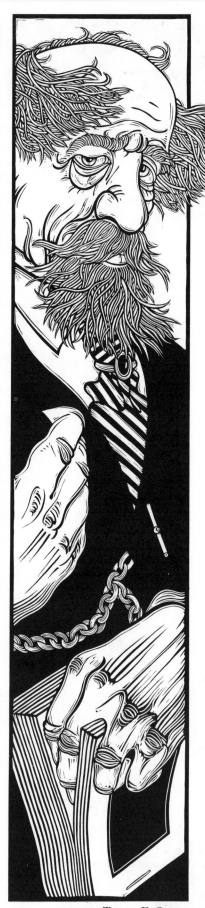

*White lines incised into black areas usually indicate an intaglio technique such as woodcut, linoleum print, or scratchboard. It is often impossible to discern the difference once the illustration is reproduced.*

*In this portrait of Charles Dickens, the artist exploited the strong linear and graphic qualities of wood or linoleum prints in the more direct and expeditious alternative of scratchboard.*

TERRY E. SMITH

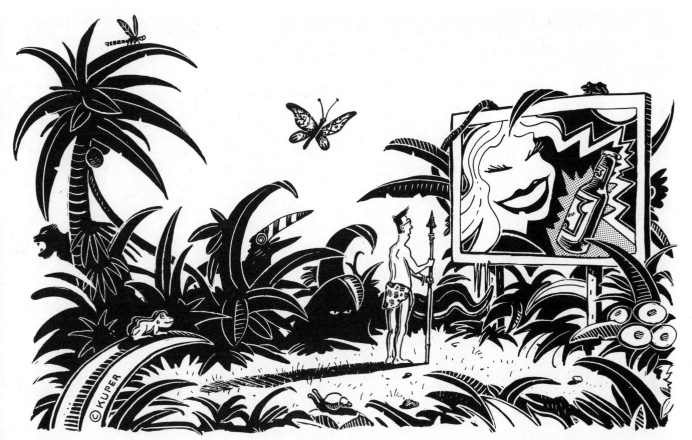

PETER KUPER

*Similar in appearance to a woodcut and whimsically drawn, this editorial drawing has strength in simple shape and line.*

RANDY LYHUS

*Light and shadow are rendered simply but emphatically. While the drawing would be identical in a block cut, it would have been a laborious process to achieve nearly the same results.*

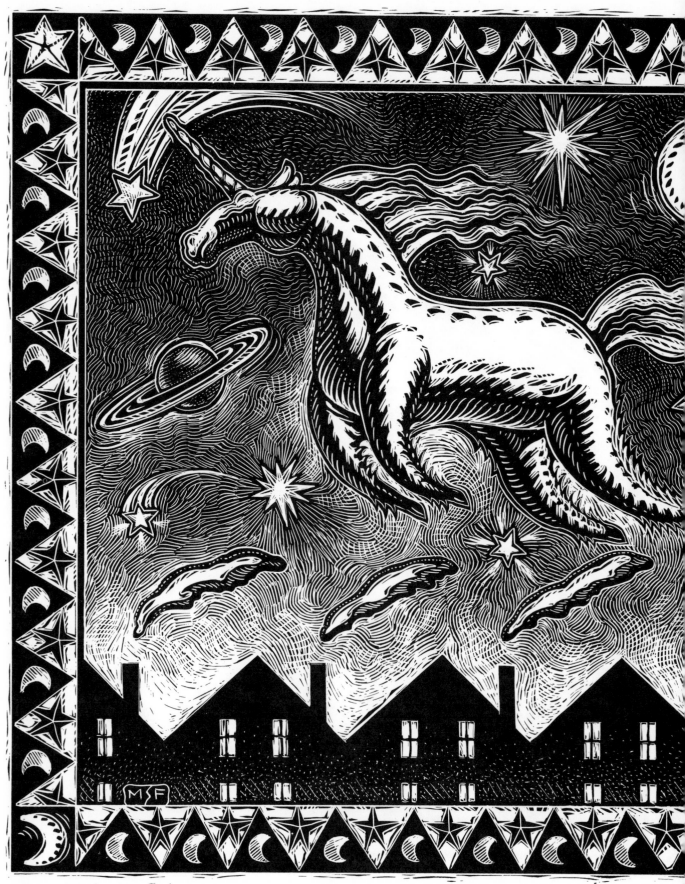

MARY S. FLOCK

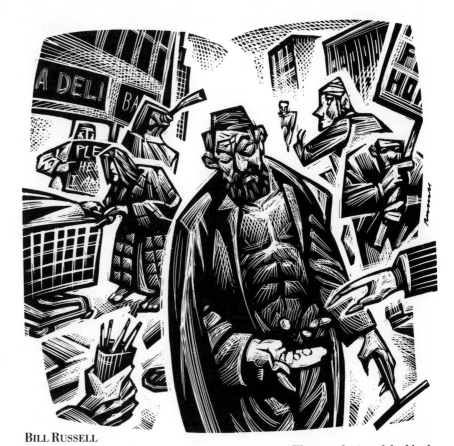

BILL RUSSELL

*The angularity of the black shapes and the white detail can also suggest woodcut.*

*The decorative border repeats elements from within the drawing and reiterates the importance of shape as well as line.*

*Using parallel hatch marks, the artist chose a sculptural effect to render the strong yet sensitive face of Czeslaw Milosz.*

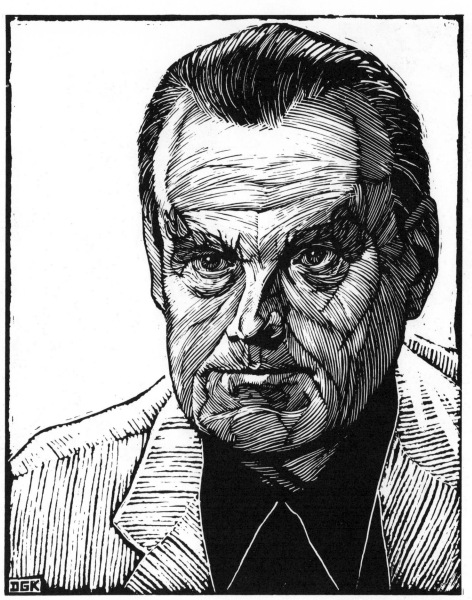

DAVID G. KLEIN

JENNIFER HEWITSON

*This spot illustration appeared as a small but important decorative element on a page of text.*

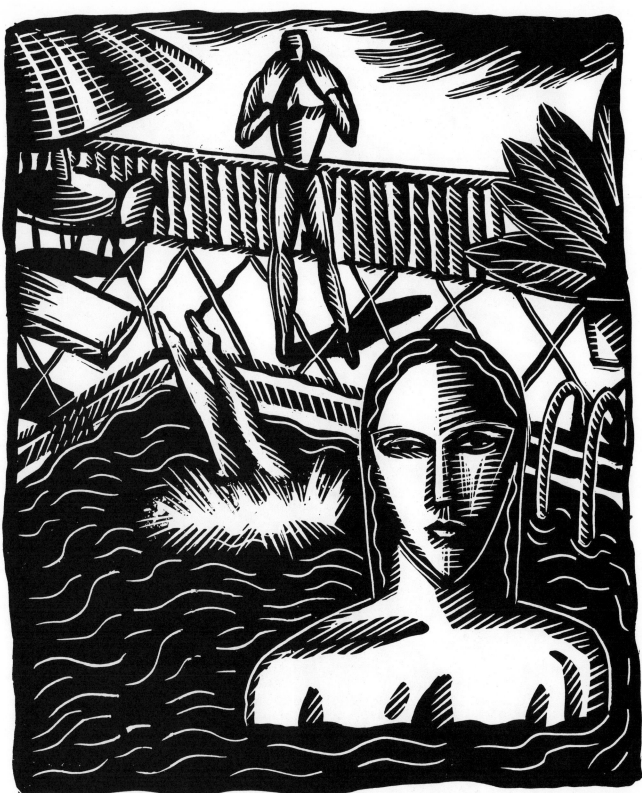

ANTHONY RUSSO

*This strikingly direct illustration gives the impression of a linoleum print. A boldly painted drawing is then enhanced with white line detail using a scratchboard tool.*

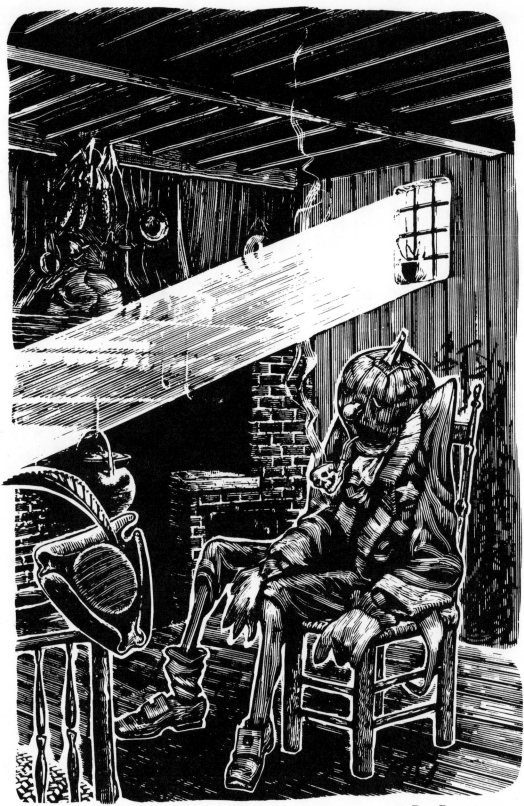

BILL RUSSELL

*This artist employs a homemade multiline tool consisting of a quarter-inch section of a metal hacksaw blade placed in an X-Acto blade holder. This creates crisp yet narrow bands of parallel lines to achieve tone, much like painting with a brush. The multiline effect is reminiscent of an engraving.*

# WOOD AND METAL ENGRAVING EFFECTS

Many scratchboard illustration techniques can create the look of wood or metal engraving. For example, by using a multiline tool (often an actual engraving tool), you can scratch fine parallel lines. You can draw these lines across the contour of a volume and crosshatch them in black ink or with white scratched lines to create the intricate linear value systems of an engraving.

Another common effect is obtained by the use of a modulated and gradated line and/or scratch. The thick and thin of the line will follow the contour of the volume, enhancing its three-dimensionality. Precise and controlled fine lines will meticulously render form and value and give the impression of engraving. The extremely impressive and rewarding results make it worth applying these laborious and exacting techniques. And these effects have the advantage of being created without the mechanical concerns of actual engraving.

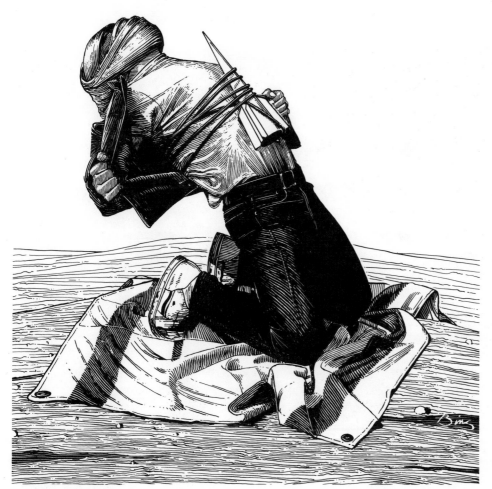

*Careful rendering of volume by using lines that follow contours is a technique also used in engraving. This artist, like many others, likens his working technique to carving stone.*

CHRISTOPHER BING

*The strength and gleam of metal armor is shown here as vividly as if it were indeed incised in metal.*

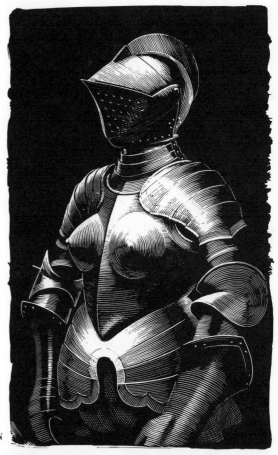

SCOTT
McKOWEN

*The fine and graceful lines that the artist has scratched in evenly spaced and parallel strokes enhance the wood-engraving look.*

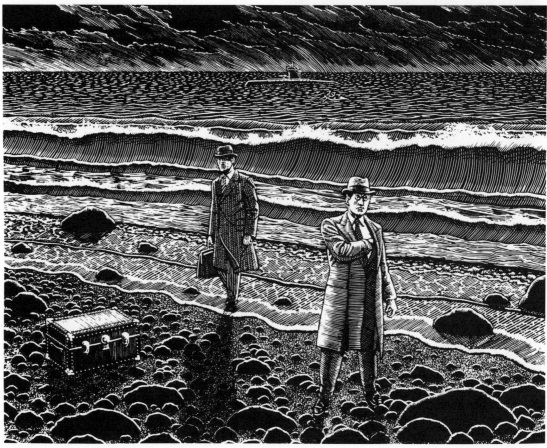

DOUGLAS SMITH

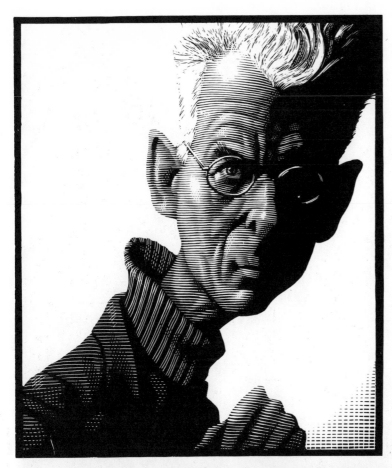

*In this portrait of Samuel
Beckett, a finely controlled
system of gradated lines
and scratches is contained
within a tight silhouette and
crosshatched with ink and
cuts.*

MARK D.
SUMMERS

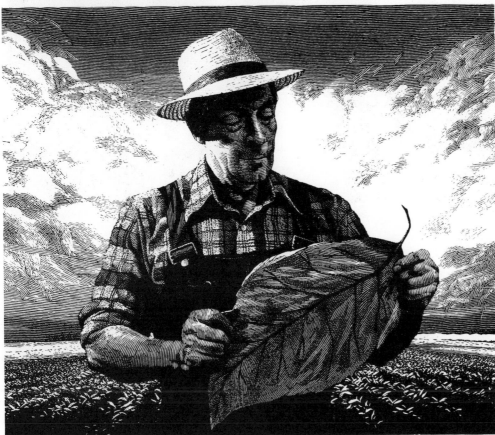

*Small strokes and
dashes created a seam-
less transition from ink
to scratches.*

HARLAN C. SCHEFFLER

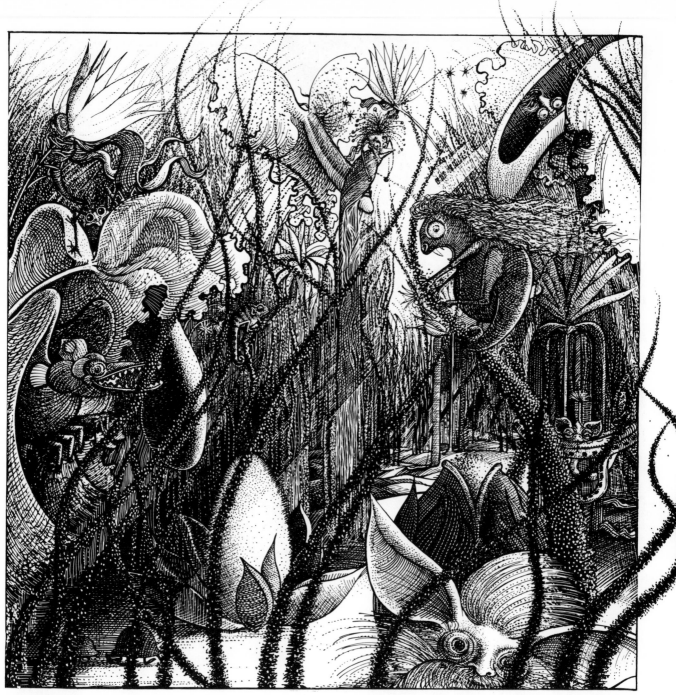

*The artist has used a great variety of line styles to develop this fantasy illustration. Notice the blurred edges of the foreground grasses to introduce the dreamlike contents of the picture.*

*After a very tight pencil drawing was transferred to white scratchboard and inked in, an X-Acto knife #11 was used to scratch in the detail and values. The illustration was printed as a duotone of black and blue with a yellow chart superimposed in the figure's left hand.*

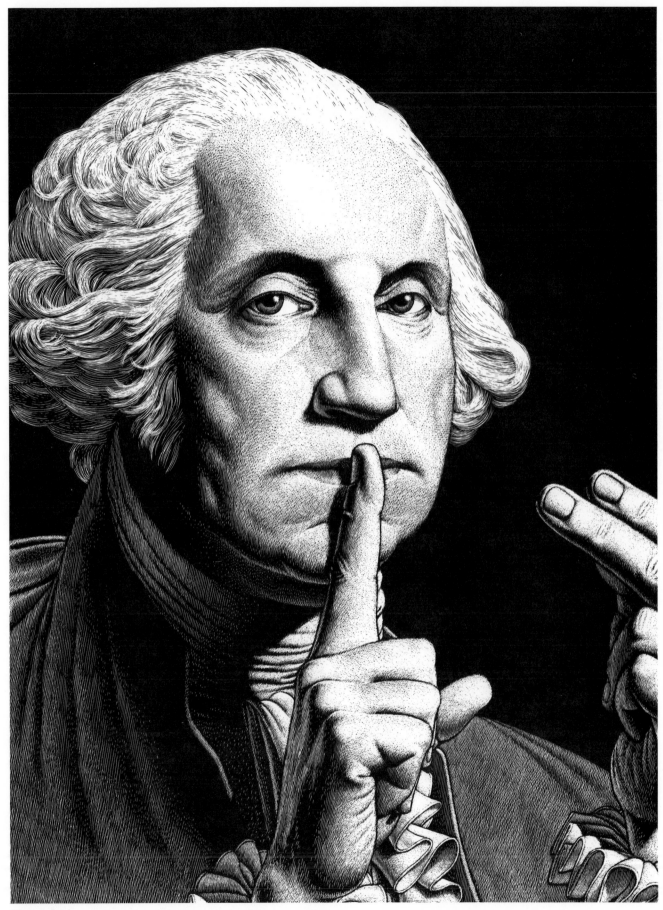

MIRKO ILIĆ

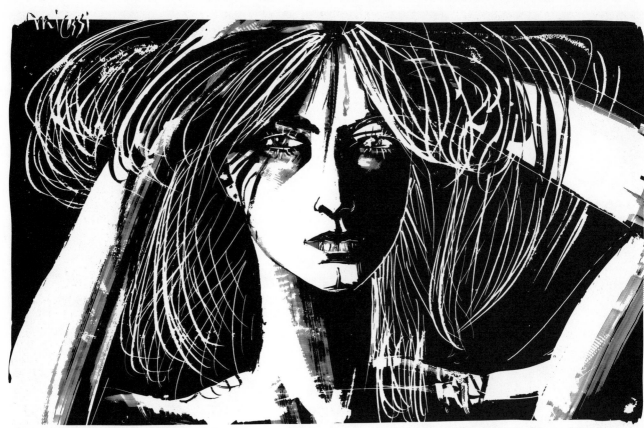

MARIO MICOSSI

This artist's distinctive style is often characterized by an exciting play of expressive lines freely laid in shapes and delicate parallel multiple lines used for pattern or value. The dramatic effect of the loose abandon of the lines used for the hair would be nearly impossible to achieve in another drawing medium. An intaglio process would otherwise have to be chosen.

In this illustration, delicate parallel multiple lines are contrasted against freely inked shapes.

MARIO MICOSSI

A subject that is actually carved and chiseled is rendered in scratchboard as if leaving the parallel lines of the sculpture tool.

DAVID KLEIN

KATHERINE L. IKEDA

*Although this spot is small, it is close to life size. It allows the viewer to observe the structure and detail.*

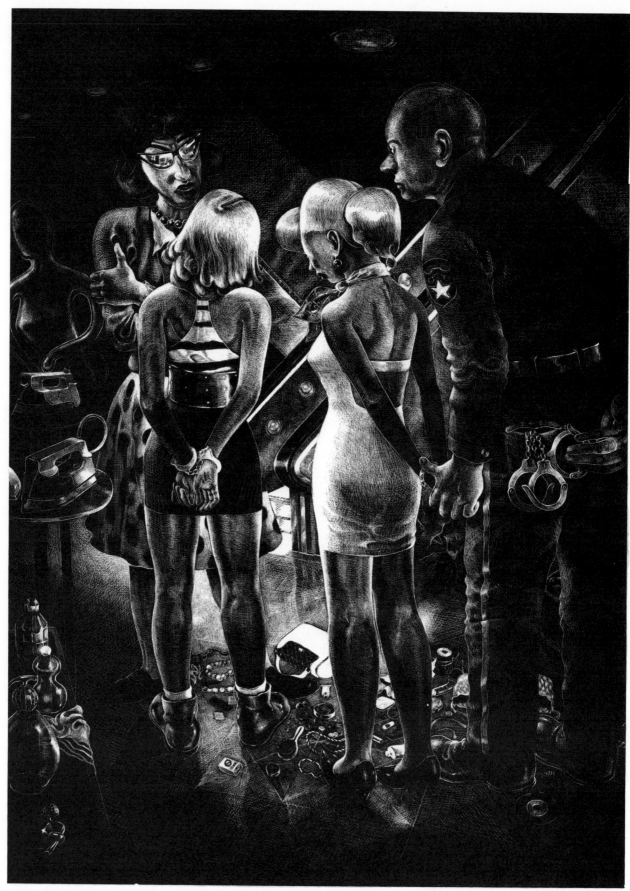

SCOTT GILLIS

# BLACK SCRATCHBOARD

Creating an illustration on black scratchboard rather than white is obviously somewhat different. If you want the final drawing to be mostly black or if you plan to scratch and work into the entire composition with white line, texture, and marks, choose the black surface. Conversely, if there are large, open white areas in your design, it is simply impractical and tedious to scrape away large amounts of black.

You may begin sketching directly onto the board with a knife or stylus, or you may wish to transfer a planned drawing. Rub the back of your drawing with a bright- or white-colored chalk or with a red Conté crayon, or simply use the yellow Saral paper. You can also use graphite paper or carbon paper, although it is somewhat difficult to see the transferred marks on the black surface. If you use carbon paper, adjust your drafting table lamp so that the light rakes across the surface and you will be able to see the transferred lines.

Red chalk is efficient, since it can be seen easily against black. However, be careful not to smear the red chalk into the white areas. Red will be read as black when it is photographed by the printer.

Your task now is to reveal the light out of the darkness by drawing with a scratchboard tool. Each scraped line etches a line of light; each mark becomes

a glint, a shimmer. A word of caution in correcting these drawings. After the line or area has been scraped, it is impossible to work back into it with black line and maintain much control. Certainly you can blacken out scratched areas completely, but once the surface has been disturbed by scratching, its smooth predictable quality has been lost.

Illustrations done in black scratchboard tend to be highly dramatic, since this medium readily exploits the theatrical aspect of light. Night scenes, for instance, are an obvious natural subject for black scratchboard.

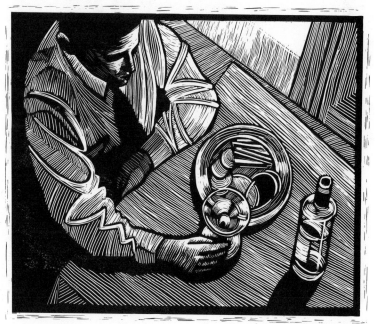

STEPHANIE SHIELDHOUSE

*Strong contrast is enhanced by solid blacks. Hatch marks laid in broadly indicate planes and direction.*

*Theatrical lighting exploits the tense drama of the situation. Traditional crosshatch technique in reverse (scratches) reveals detail and form.*

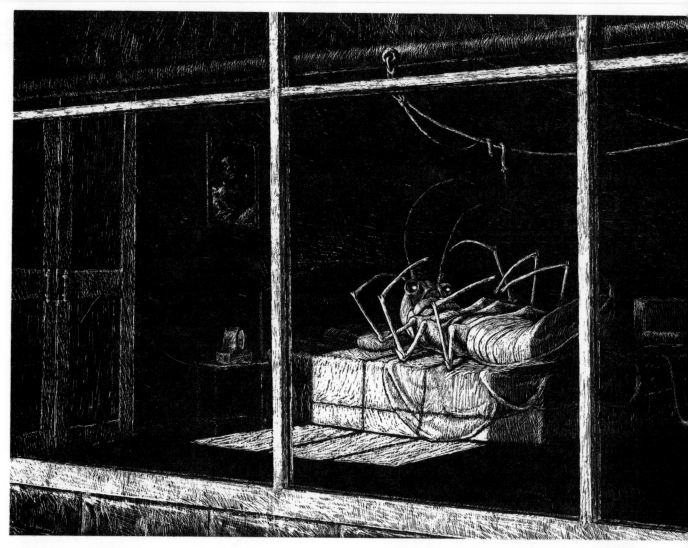

*In this illustration, light focuses attention on specific areas and details of the composition.*

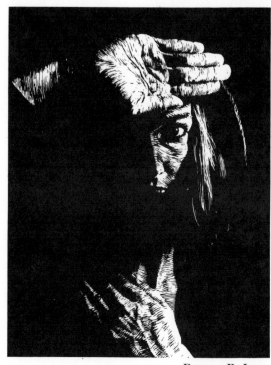

*For this intensely realized portrait that emerges out of the darkness, black scratchboard was an obvious choice of medium.*

PAMELA R. LEVY

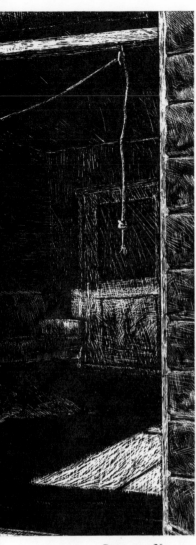

GREGORY NEMEC

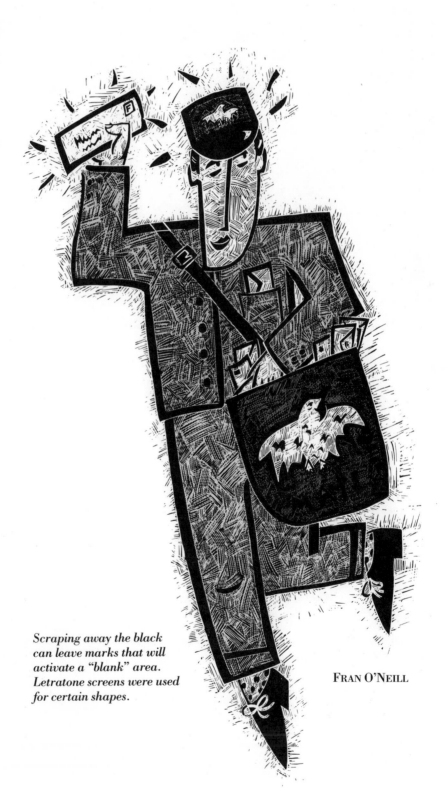

*Scraping away the black
can leave marks that will
activate a "blank" area.
Letratone screens were used
for certain shapes.*

FRAN O'NEILL

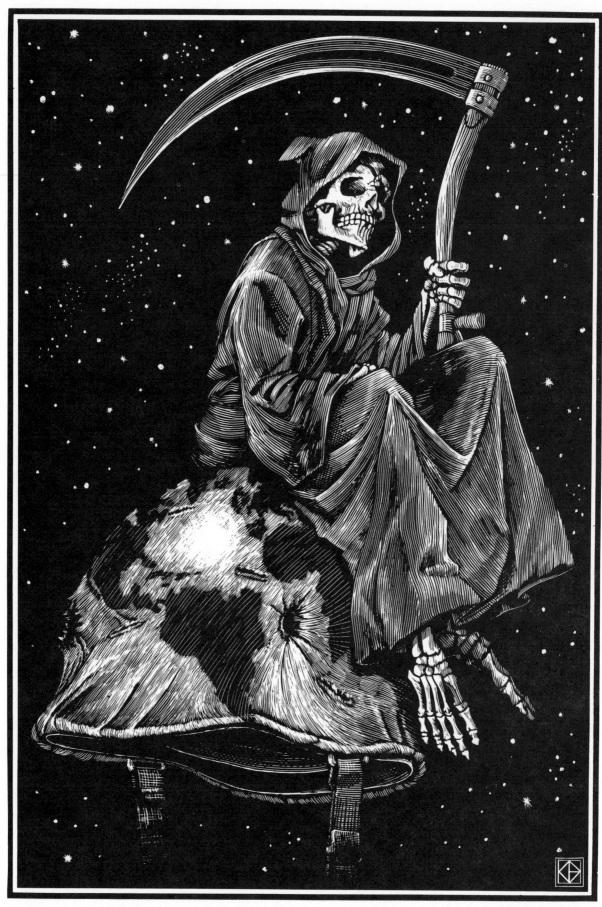

KENT H. BARTON

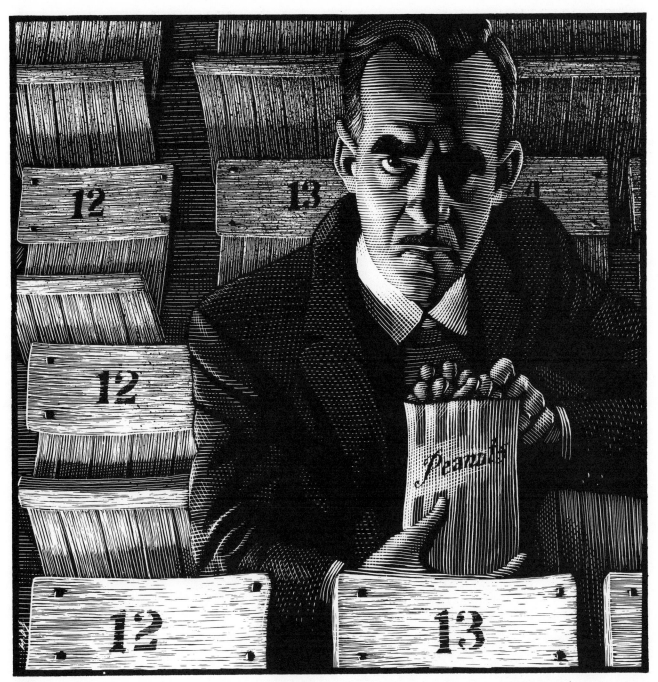

MARK D. SUMMERS

*Ballpoint pen sketches were done on tracing paper and transferred onto black scratchboard, which was then scratched with X-Acto knives. In some instances, a full tonal oil painting was done to work out the values before proceeding to the scratchboard.*

*Black scratchboard is often used for ominous or sinister subjects, since black can project power and strength.*

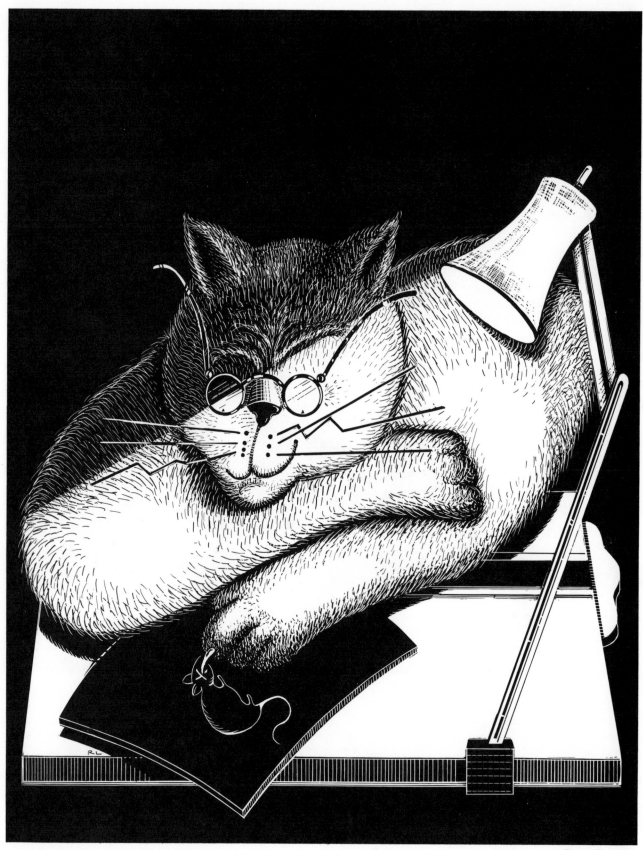

*The light and shadow here serve compositionally to divide the drawing into large bold shapes. The drawing relies heavily on the positive/negative interplay of these areas.*

RUTH LOZNER

# LIGHT AND SHADOW

Images are revealed to us through light. The uniqueness of scratchboard forces the artist to deal with the contrast between light and shadow. This act of "pulling" highlights out of darkness by scratching white lines out of black-inked areas is akin to chiaroscuro. In chiaroscuro, used traditionally for drawing and painting techniques, the artist revealed objects in the darkness by focusing on the highlighted areas. Dealing with light in such a manner can provide profound drama and intensity. The scratchboard artist creates a similar effect in the scratchboard medium by working in reverse. In scratchboard, especially in black scratchboard, the artist scrapes out the light, leaving shadows and dark areas untouched.

The direction of the scratches or drawn lines helps to indicate volume and three-dimensionality. The character of the subject helps determine the style of the cut or drawn lines.

Note that the accompanying illustrations have several elements in common: The light source is intense and uncomplicated; areas of light are contrasted directly or juxtaposed closely to areas of dark; and the direction, width, or style of the line and mark can change relative to the light or shadow. These characteristics allow the artist to dramatize the impact of the subject and further define its three-dimensional solidity. Light and shadow on organic objects may be subtly rendered around the contour. Light and shadow on man-made objects tend to be more hard-edged and simplified into shapes.

Remember that it is the nature of scratchboard illustration to make its impact through the dramatic contrast of light and shadow. Light and clarity of focus reveal detail. The contrast of black and white lends strength and impact.

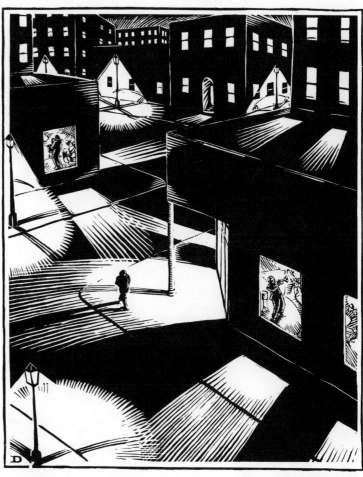

BOB DAHM

*This dramatic drawing intentionally pays homage to the woodcut artists of the 1920s and 1930s. There are no real intermediate values—strong highlights emanate equally from each light source leaving solid black shadows.*

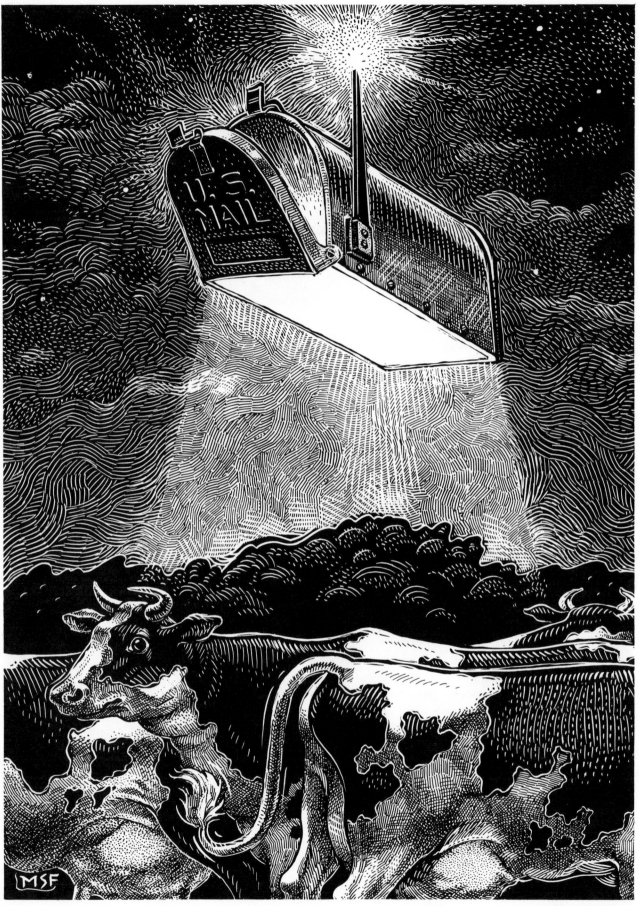

MARY S. FLOCK

*The light and shadows were created by lines that change in width and density.*

*A single light source helped define the three-dimensional forms and gave solidity to the volumes.*

*In this artist's adaptation of Edvard Munch's painting* The Scream, *we see Paul Klee and Henri Matisse in the background with Munch in the foreground. The technique used focuses attention by more involvement with value and texture in certain areas than in others.*

LEONARD EVERETT FISHER

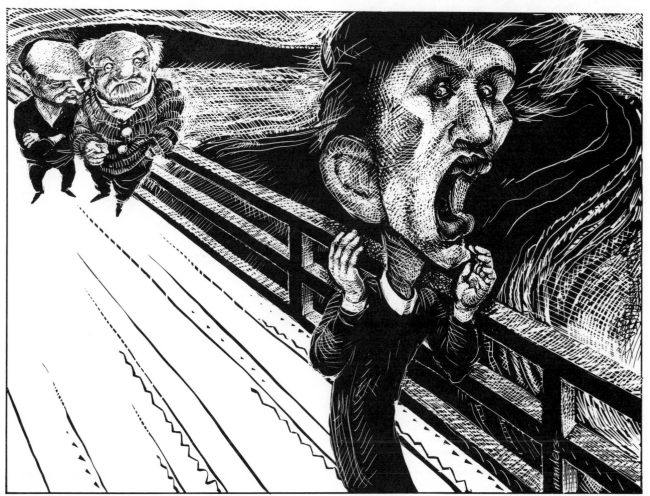

JOHN MANDERS

RUTH LOZNER

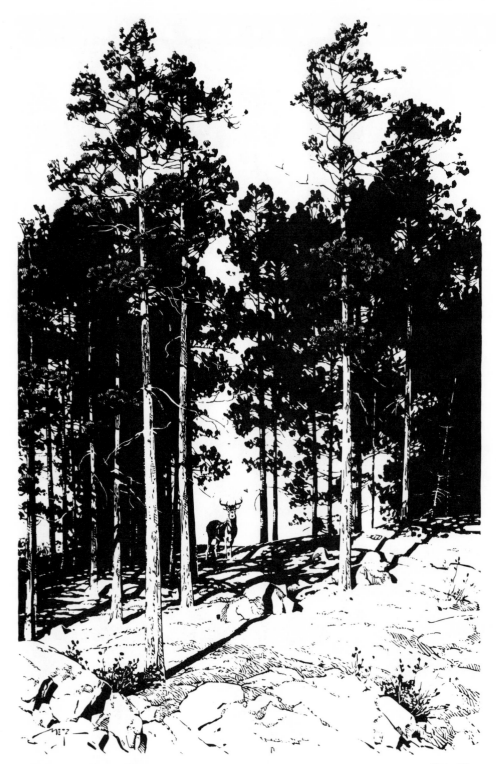

*This subject lent itself quite naturally to scratchboard. A flash of light revealed the subject in a frozen moment and created silhouettes against the sky.*

DAN METZ

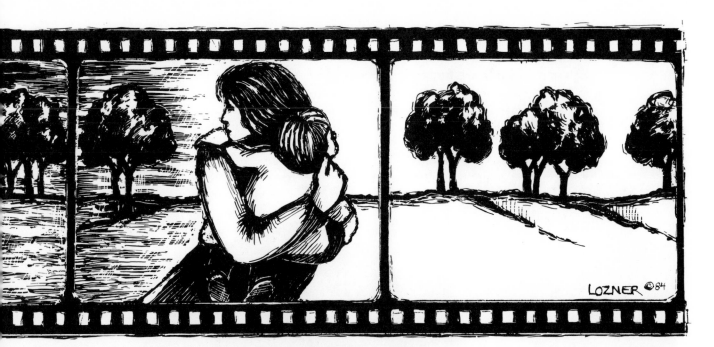

The use of light and dark in the background works both as a metaphor for the concept and as a visual device to help progress the frames of the drawing in time.

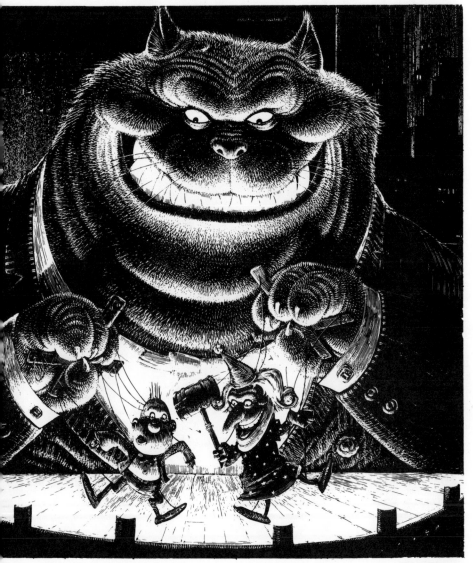

Scratchboard techniques can describe texture and three-dimensionality of form when focusing on light and shadow.

BILL MAYER

## ACHIEVING TONE AND VALUE

As stated before, both scratchboard and pen and ink are linear techniques. The difference between the two is in the approach: In the former, the tone and value are defined by scratching white out of the black; in the latter, you are adding black to white. In scratchboard, you are adding black to white as well as working in reverse by cutting white into black, scraping away the inked surface and revealing the white chalk below. In both scratchboard and pen and ink, the resulting mixture of black and white creates value, the eye blending the light with the dark. Here, you can see how some artists have dealt with this issue.

*The artist's meticulous use of fine lines and scratches develops a subtle gradation of tone. A strong light source from the left has helped reveal the full range of values from pure white to pure black.*

PAUL E. SHELDON

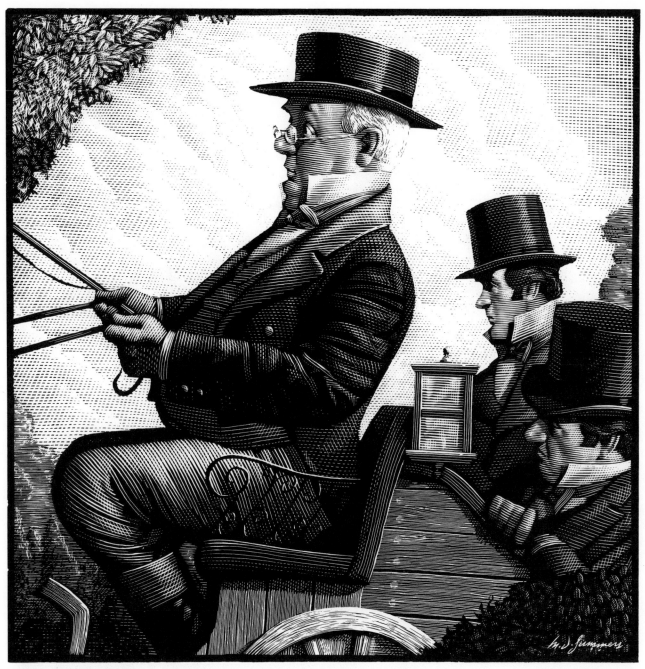

*Lines crossed with ink and scratches created three-dimensionality and solidity. The backlighting brings out the strong silhouettes of the figures. This careful technique creates smooth modeling of form while retaining bold graphic contrast.*

MARK D. SUMMERS

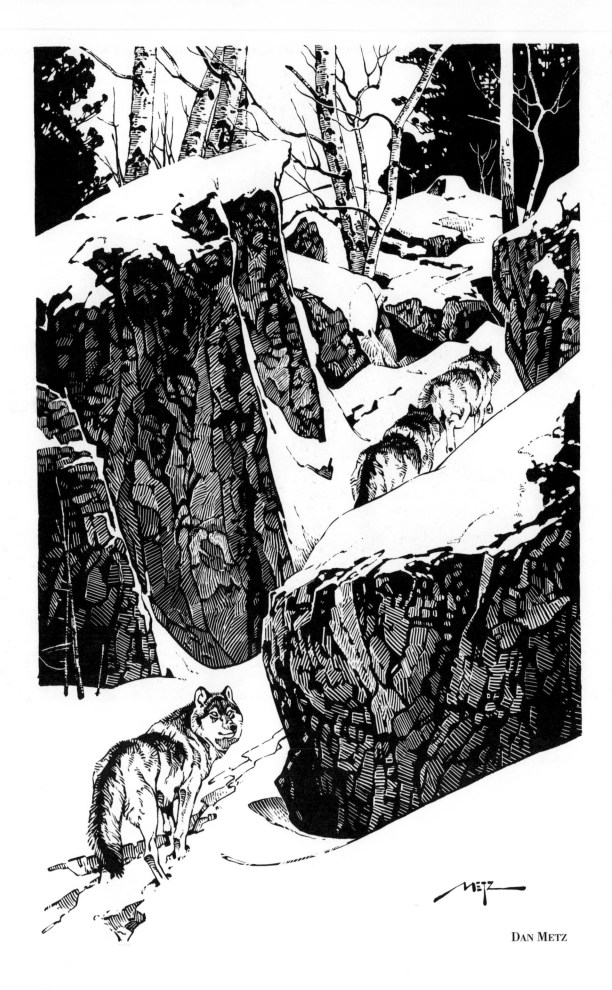

DAN METZ

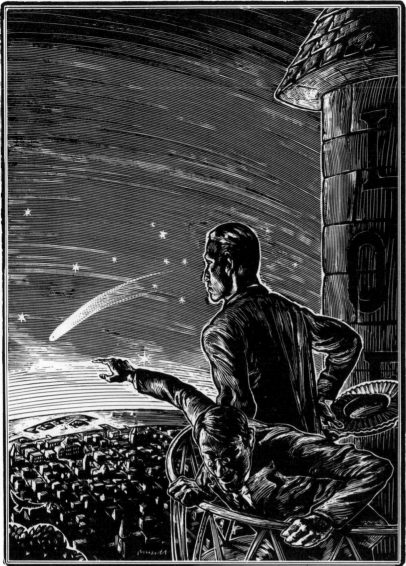

BILL RUSSELL

The entire surface was manipulated by lines and scratches. Although the overall composition is dark, there is a wide range of value.

A unique technique of rendering value is used here: clusters of three or four short parallel hatch marks drawn with thick and thin technical pens as well as scratchboard tools.

The power of this vertical composition is created by the upward thrust of the dark rock formations rising out of the white snow and ending again with white sky or snow at the top.

DAVE HUDSON

## SOLID WHITE AND SOLID BLACK

Scratchboard naturally lends itself to stark contrast—bold strong form, deliberate line, open spaces. The preliminary stage of blocking in or inking in the major black areas and lines encourages an abstract approach to the composition through simplification of large areas of black and white. The whole composition can be laid down quickly and expressively. In certain instances, very little scratching has to be done.

Solid blacks suggest intense power and strength, vast depths, or deep shadows. Compositionally, blacks provide dynamic impact. Areas of plain white are essential parts of the composition and can create similar impressions. Large areas of white provide openness and relief as well as light, bright local color.

The examples here address the issue of solid black or white in several ways. Common to all is the power of contrast.

RUTH LOZNER

*The stark white background and black body, contrasted against the finely rendered face, reiterates the concept presented in the article concerning the importance of one's specific identity.*

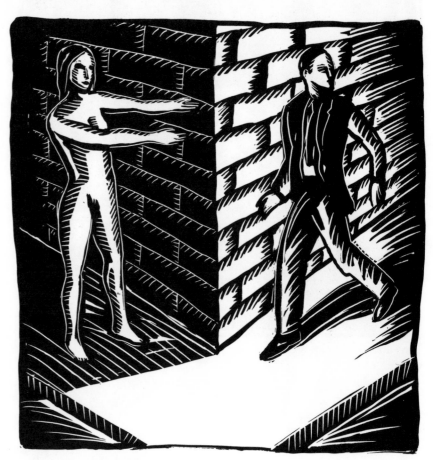

ANTHONY RUSSO

*The use of solid black and white again visually reconfirms aspects of the intellectual concept of the illustration. Note that white lines function as outline, detail, value, texture, and motion.*

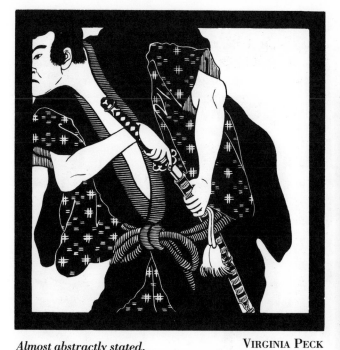

Almost abstractly stated,
this drawing relies heavily
on shape—black, white,
and patterned.

VIRGINIA PECK

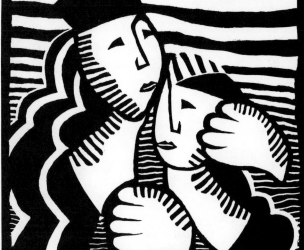

ABBE ECKSTEIN

*This illustration is mostly
involved in line—its func-
tion as pattern, value, and
outline to describe shape.*

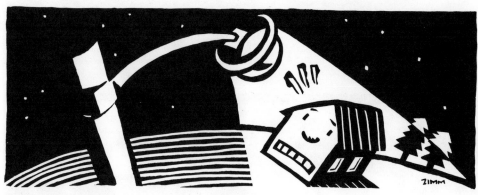

ROBERT ZIMMERMAN

*This illustration seems
equally reliant on line and
shape. It is the solid black
and solid white, however,
that creates its strength.*

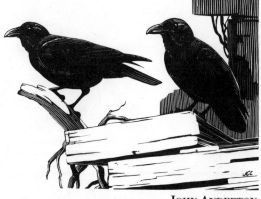

*With few fine white lines
defining detail, the black-
ness of the birds becomes
strongly emphasized
against the solid white sky.*

JOHN ANDERTON

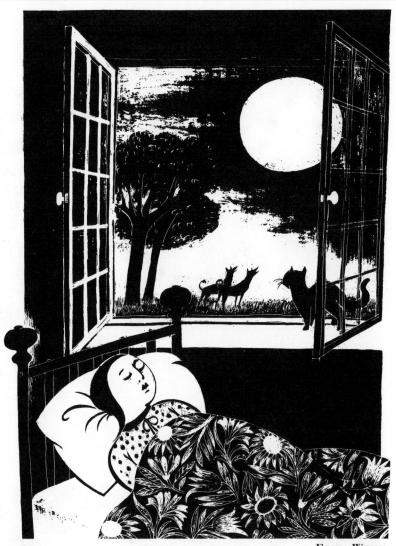

*Framed in black, the tightly rendered pattern on the bed contrasts with a looser, more textured effect in the landscape.*

ERIKA WEIHS

*White silhouettes of the horses on black ground contrast with the black silhouettes of the trees on the white sky, all softened with textural marks.*

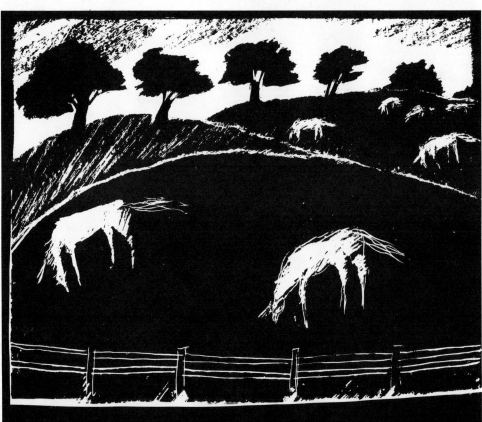

MARGARET
GEORGIANN

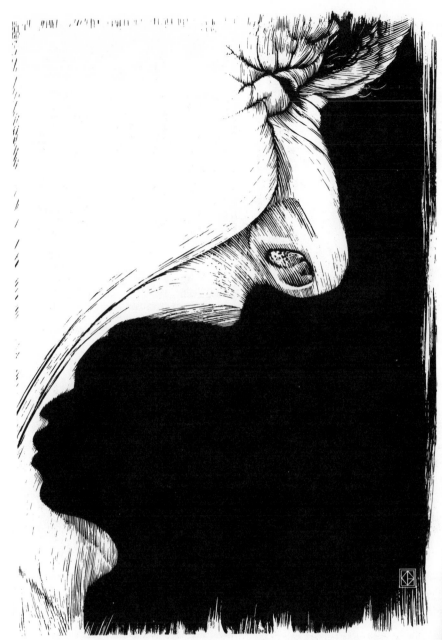

Kent H. Barton

*A positive/negative reversal in concept and color created a powerful illustration. Note the brushstroke edges.*

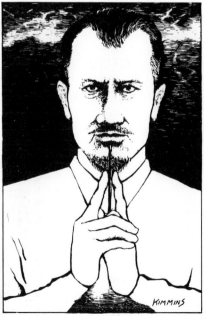

PETER KIMMONS

*Attention to detail and value is reserved for the face, which enhances the intensity of this portrait. The body, hands, and background are simply stated in mostly solid black and white.*

This artist employs an exacting technique to render these illustrative letters. Used as the initial capital letters in the beginning of a paragraph of type, spots such as these provide graphic interest and relief as well as tie the type in a visual way to the subject matter of the text.

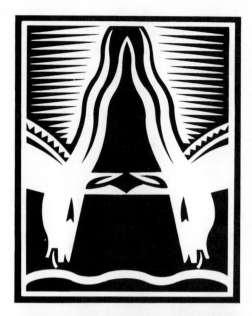 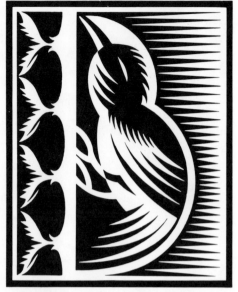

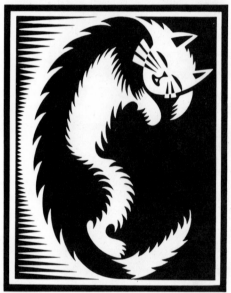 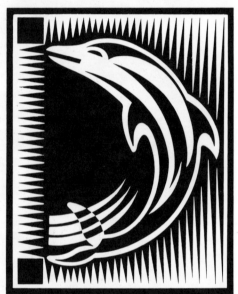

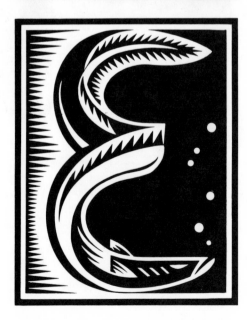 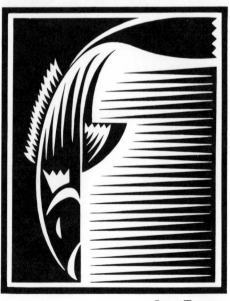

JEAN TUTTLE

# SPOT ILLUSTRATIONS

Scratchboard lends itself very well to small spot illustrations. Spots, which are the bread-and-butter jobs for illustrators, tend to be simple, bold, and graphic, and can be produced quickly. Most newspapers and magazines need many spot illustrations per issue. Spots provide graphic interest to break up an otherwise solid page of type. One category of spots is the initial capital letter, which is especially effective in this medium, since the strong black-and-white contrast juxtaposes effortlessly with the text type.

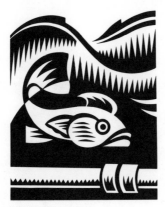
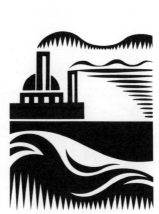
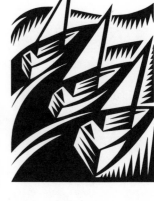

JEAN TUTTLE

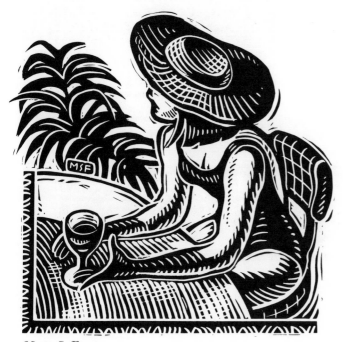

MARY S. FLOCK

*Spot illustrations are characterized by a relatively simple graphic style.*

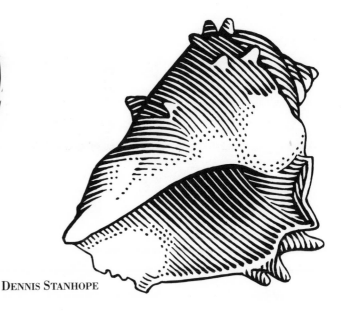

DENNIS STANHOPE

*Whimsically drawn initial capitals reflect the humor and content of the text.*

PETER KUPER

JOANNA ROY

*Highly decorative, this initial letter reflects the style of the original illuminated Indian text.*

*The metaphoric change and movement in this spot illustration is further emphasized by circular marks around the figures and ball.*

JENNIFER HEWITSON

SCOTT McKOWEN

*Shakespearean characters
illustrate letters for an ad-
dress book:
F—Falstaff
W—Old Widow of Florence
X—Sir Pierce of Exton*

*In all these examples, the letters are
superimposed over spot illustrations.
With scratchboard, the typography
can be tightened and refined to blend
effortlessly with the rest of the
phototype.*

GREGORY NEMEC

*These spot il-
lustrations were
part of a series
on children's ac-
tivities. The
inked line that
was used is rough
and sketchy, and
while the scratch
mark is quite
fine, the draw-
ings were re-
produced same
size as the origi-
nal, interspersed
in a full news-
paper page of
text.*

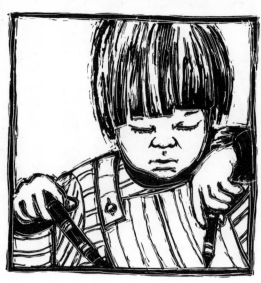

**RUTH LOZNER**

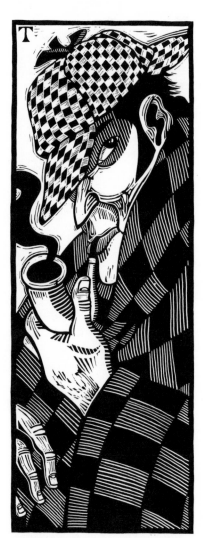

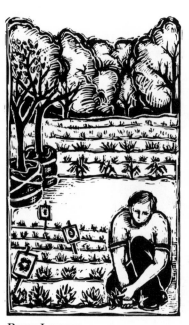

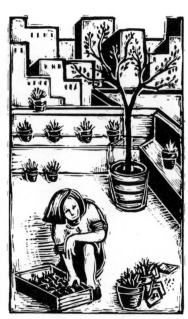

**RUTH LOZNER**

*Illustrating an article on
the similarities and dif-
ferences between city and
country gardening, these
spots used that idea as the
inspiration for the similar
compositions and figures.
Each spot was used at the
top of a column of type.*

*Boldly drawn, this illustra-
tion will lose nothing in
detail when radically
reduced.*

**TERRY SMITH**

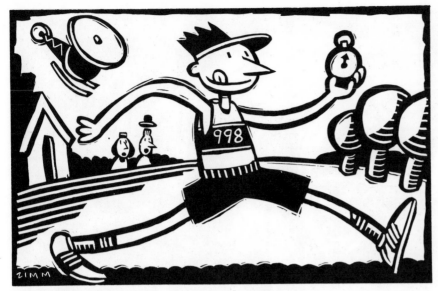

*Economically drawn and with little detail, this striking spot holds its own against type. This drawing demonstrates the suitability of technique to cartoons where clear sharp lines are desirable.*

ROBERT ZIMMERMAN

*The delicacy of the subject is consistent with the fine scratchboard technique. The small size of the spot seems appropriate for the diminutive image.*

JOHN C. ANDERTON

ANTHONY RUSSO

*Spots can actually stop the reader so that he can contemplate a visual image before moving on to the rest of the copy. A spot can deliver a very clear message.*

*This roughly hewn drawing with clearly rendered typography can be reduced as a small spot illustration.*

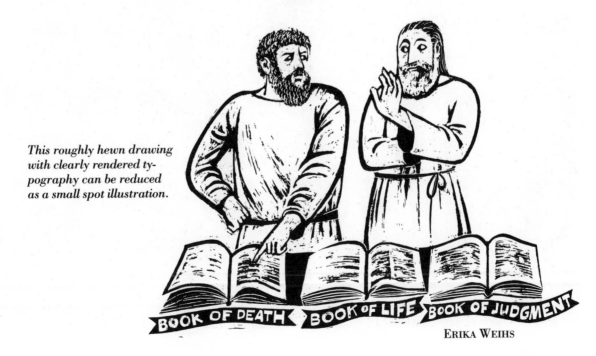

ERIKA WEIHS

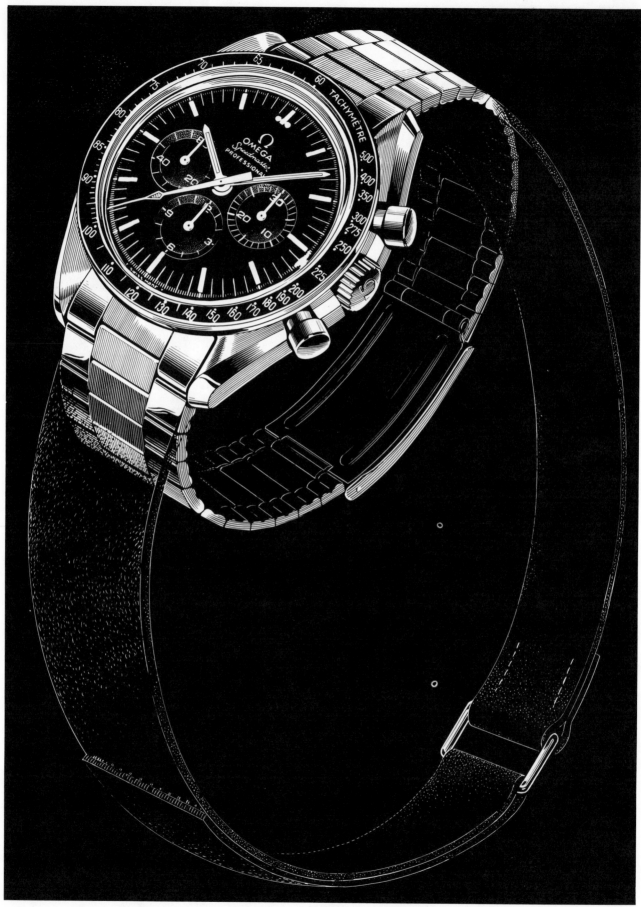

BOHDAN OSYCZKA

# TECHNICAL CONSIDERATIONS

The photomechanical technology developed in the late nineteenth century, as well as more recent advancements, has facilitated the working process for the scratchboard artist. The original can be printed in the same size, larger, or smaller. Photocopying allows experimentation with the drawing before the final is submitted for publication.

## REDUCTION/ENLARGEMENT

Since the line in scratchboard is tight and clean, illustrations in this medium can be reduced beautifully. Depending on the thickness of the line and the quality of the paper it will be printed on, the artist might prefer to work larger than the published size, commonly one and a half to three times the ultimate reproduction size. When reduced, the drawing will appear "tighter." Often the original drawing is done to the exact size of the published piece. A greatly enlarged drawing, which

seems to have a cruder quality, tends to resemble a woodcut or linoleum print. A copying machine is a handy tool for previewing the look of the printed piece without the expense of having a photostat made.

RUTH LOZNER

*The precise detail needed for product illustration necessitates that the drawing be done one and a half to three times larger than the reproduced size.*

## PHOTOCOPYING

Before the completion of a black-and-white scratchboard, it is quite helpful to have it photocopied. A *good-quality* copy, in which the blacks are dark and solid and the integrity of the detail is retained, can serve several purposes. It allows you to preview the drawing in the size in which it will be reproduced and to make last-minute minor corrections with ink or opaque white-out paint, such as Dr. Ph. Martin's bleed-proof white. Since a final photocopy can serve as the camera-ready original, you can keep the scratchboard original. Be sure to make additional prints for your records and for future use.

The very thin grade of scratchboard, when it is cut to 8½″ × 11″, can be put through some copying machines, printed, and rescratched if necessary. An added benefit is that some of the distortion features on the photocopy machine produce quite interesting and unexpected effects.

## WORKING TIPS

Although there are many benefits to scratchboard, there are a few problems. But none of them is insurmountable.

The scratchboard technique can be extremely time-consuming and laborious, depending on the style and magnitude of your work. The more detailed, larger illustration demands more time. Holding the scratchboard tool too tightly for extended periods of time might result in a hand cramp. The work demands that you hold your hand in a certain position and repeatedly apply slight pressure onto the board's surface. With some tools, the knife or nib might rest uncomfortably on your middle finger.

To alleviate these problems, take the following precautionary measures. Take breaks. Give yourself plenty of time to complete complicated pieces. During these breaks, gently massage your hand, shake it out, and rest it. Wrap the scraping tool handle with masking tape. Better yet, use a strip of foam rubber, cotton padding, or an adhesive bandage. You might also wear the adhesive bandage on your middle finger. The nib will not leave an impression on your finger and the pen will be much more comfortable to hold.

A large scratchboard illustration, which requires a great deal of scraping, will produce quite a lot of chalk dust. Use a drafting brush or soft chamois cloth to clean the dust off your board and desk. Brush the dust onto a sheet of paper placed beside your board. As the dust collects, periodically wrap up the paper and toss it away, then start with a clean sheet.

Thicker scratchboard is a bit difficult to cut into smaller pieces. Use a utility knife with the scratchboard placed on a rubber cutting surface. Use a metal straightedge or T square to control the cut, and watch out for your fingers! The thinner boards can be cut with scissors.

Since you will find yourself at some time working in fine detail, eyestrain is also possible. A good drafting light is absolutely essential, either with a magnifying glass attachment or with a separate standing magnifying glass. However, wearing prescription glasses that have a slight magnification is optimal.

*This illustration was used as art for an actual engraved medallion.*

RUTH
LOZNER

# NONTRADITIONAL APPROACHES

Artists often push convention aside and take license with traditional materials and techniques. Scratchboard lends itself to ingenious new approaches to black-and-white drawing. Any deviation from the standard of the smooth board, India ink, and scratchboard tool can yield unique and personal expression. You might learn from these different approaches and apply them to your own work.

In addition to the standard smooth black-or-white scratchboard surface, textured and embossed boards are available from Essdee/British Process Boards Ltd. Black textured boards are worked in the same way as plain black, but graduated tone effects are obtained by stroking the knife blade more or less lightly across the raised patterns (such as embossed crosshatching or parallel lines). The tops of the patterns become white, leaving the black pattern defined. With white textured board, these patterns are revealed when black ink is lightly brushed across the raised textures, leaving the crevices white. Suede finish board, which has a nearly invisible texture, is quite receptive to dry media, such as graphite, carbon dust, or lithographic crayon. White clay-coated papers, such as video or media paper, are also available. Their thin clay surface cannot be rescratched and corrected.

For some illustrations, you might want to achieve greater variety of textures and tonalities. The variety of films of printed screens and films by Letraset, Prestype, or Chartpak are commonly used in conjunction with scratchboard. Still photographed as pure black, screens can add a more mechanical texture or tonality to the illustration. Another possibility is to collage cut paper—either photocopies or preprinted paper onto a scratchboard drawing.

To soften the effect of the black scratchboard line, you can rub black chalk or pastel into the scratched line and have it shot as a halftone. You can also use graphite black pencil, black colored pencil, or lithographic crayon on smooth or embossed scratchboard surfaces.

You can obtain other textural effects by using an airbrush, an atomizer, or a toothbrush for splatter or granular textures. You can produce still other effects by "printing" textures of fabrics or sponges soaked in ink. Rubber stamps or handmade eraser stamps yield still other variations.

To create rich, sensitive tones and gradations, try using other multimedia techniques, such as ink washes and pencil drawing on white scratchboard, with scratched detail and highlights. Let your imagination run free and discover new combinations of media and methods that work particularly well for you.

*Here, preprinted Letratone screens were used to add gray tones of a different texture.*

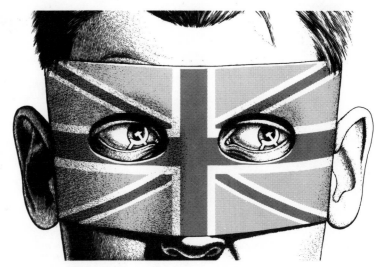

MIRKO ILIĆ

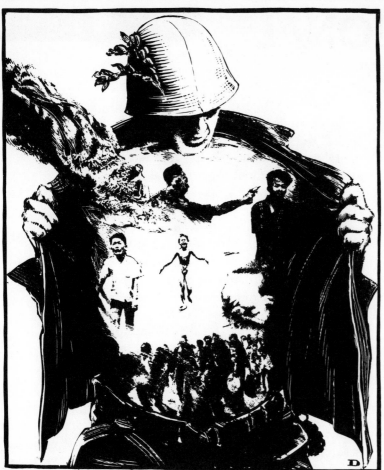

*Photocopies of photographs were transferred onto a simply drawn figure. Ink wash was then used to integrate the photocopied images with the rest of the drawing.*

BOB DAHM

*Photo credits: Eddie Adams, UP*
*Huynh Cong Ut, AP*
*Nik Wheeler, Black Star*
*Malcolm Brown, AP*

*Photostats of official seals were collaged onto the scratchboard drawing.*

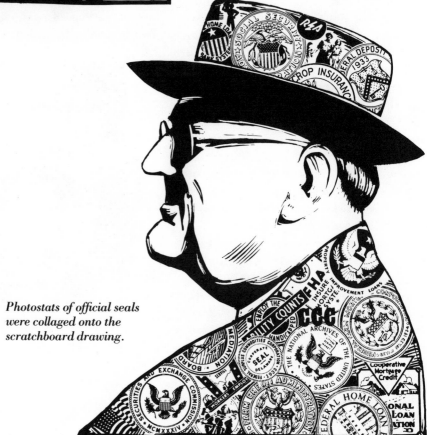

BOB DAHM

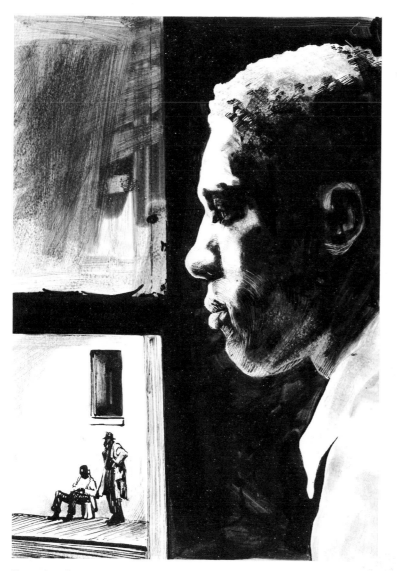

*In addition to conventional scratchboard tools, a reed pen and a piece of cotton fabric were soaked in ink and rubbed on with a finger to create the textural effects in this drawing. Like other drawings that use gray or ink wash, this drawing was reproduced as a halftone.*

DOROTHY LEECH

*The unique technique used in these illustrations has its roots in lithography. Fabric, cut to the necessary shape and soaked in India ink, was pressed onto newsprint with a brayer to rid it of excess ink. The wet fabric was then laid on the scratchboard and rolled again with the brayer (similar to the use of tusche for transferring texture onto a lithographic stone). When the ink was dry, the rest of the drawing was put down with Korn's soft lithographic crayon. The lines and details were then scratched out with a #24 X-Acto blade.*

MARGARET GEORGIANN

Often it is desirable to incorporate scratchboard detail, such as the faces of the cats, with an actual linoleum print.

FRANCES JETTER

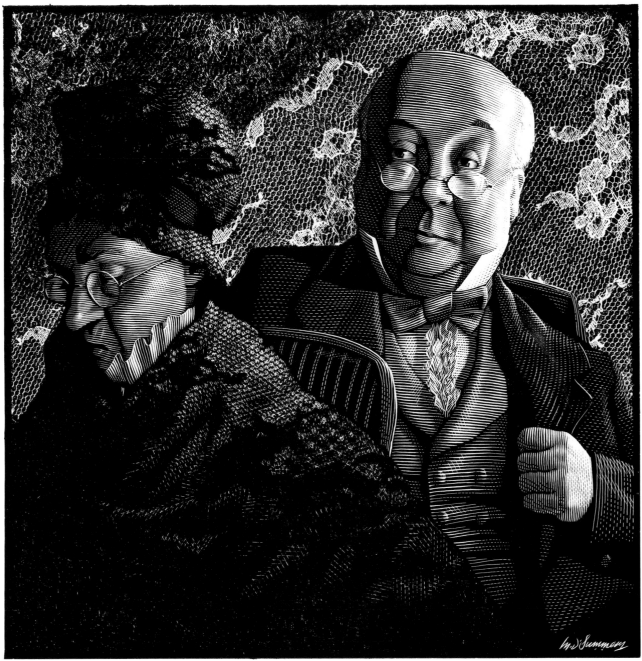

*The background and the woman's dress is actual lace laid on top of a splattered surface and photographed as a collage. A fully realized sepia painting using live models and costumes was produced as reference before the scratchboard was begun.*

MICK ARMSON

# ADDING COLOR

As shown in this book, even when restricted to the conventional black-and-white format, the potential of the medium and technique of scratchboard is vast. As with any medium, artists find that their creativity inspires them to extend the limits of the given material. By breaking preconceived notions and going beyond historic examples, artists have shown us that new art forms can be invented.

Color can act as an enhancement to traditional black-and-white drawing, woodcut, or engraving, and, likewise, to scratchboard. Frequently, color heightens an illustration's visual impact and authenticity. Practically speaking, using color allows entrance into the more lucrative color illustration market. Included are some samples of professional work in which color and the use of inventive tools, surfaces, and media have provided the means to very exciting ends. Perfection of the techniques involved in combining these media comes, as always, after an orderly methodology of experimentation, analysis, and refinement. I encourage you to use these examples as inspiration for your own inventions.

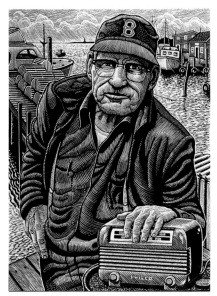

DOUGLAS SMITH

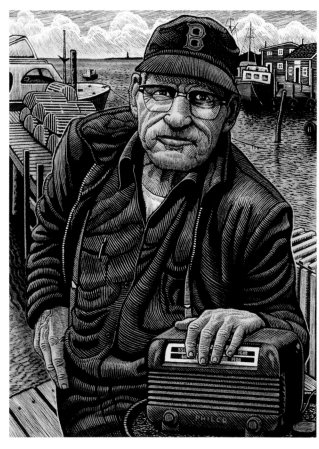

*The original illustration, done on black scratchboard, was photocopied on card stock and painted with watercolor.*

*The scratchboard technique can unify a complex and active composition. The spots of color add still more vitality and impact.*

## SURFACES

In this section, I want to discuss alternatives to the traditional scratchboard surface. Most scratchboard artists working today in color use the commercially available, higher-quality white scratchboard, such as Essdee (or, in a few cases, the black scratchboard). A smooth, consistent, reliable surface can truly be obtained only in commercial high-quality scratchboard. Therefore, I do not recommend that you make your own.

However, some artists choose to use unorthodox surfaces that reveal imperfections and surprises. Many times "happy accidents" that occur owing to unexpected imperfections lend liveliness and spontaneity that can be a joy to the artist. Artists, after all, learn about art through the act of making art.

Other related surfaces that yield interesting results are clear workable acetates or frosted films, such as Cronaflex, Herculon, Bruning drafting film, Dendril, or Mylar. These can be coated with a thin layer of opaque acrylic paint or ink.

After the paint dries, it can be scratched through with any sharp instrument to reveal a clear line. You can use any color for this coating and any method of scratching, although the character of the line is slightly different from that done on true scratchboard. It appears rougher; it looks more like a drypoint etching line. By placing the preliminary drawing under the acetate, you can apply the ink directly without transferring the drawing. This is especially effective for tracing and scraping typography. Transfer the original drawing onto illustration board and then paint it with acrylic, gouache, or watercolor, or make a collage with cut paper or whatever you wish. Next tape the scratchboard acetate overlay and board together. It's now ready to be sent to the printer to be photographed as a full-color illustration.

You may also choose to experiment with a sophisticated version of the crayon or oil pastel and India ink method of childhood. For this technique, use a double-weight piece of illustration board as the baseplate. Cover the entire surface with wax crayon, either randomly or in a more controlled way, according to a planned drawing that you might transfer using the methods discussed in chapter 3. Dust the crayon surface lightly with talcum powder before painting the black layer. Use India ink, mixed with a few drops of a surface-tension breaker, such as liquid detergent. This will prevent the ink from beading or crawling on the waxy colored surface. Let the ink dry thoroughly. If you wish, you may reuse your planned drawing and transfer it again onto the dry inked surface. Now draw directly onto the board with any of the scratchboard tools. The scratched marks will reveal the color beneath.

Another variation is the white clay surface that has been lightly roughed up with sandpaper. You can enhance the texture of tiny scratches by rubbing powdered color or metal pigments into the surface to create a rich background, onto which you can do more drawing and scratching.

*A strong black drawing was subtly enhanced with watercolor washes. The decision to leave the edges rough reiterated the emotional dynamism and spontaneity of this piece.*

KENT H. BARTON

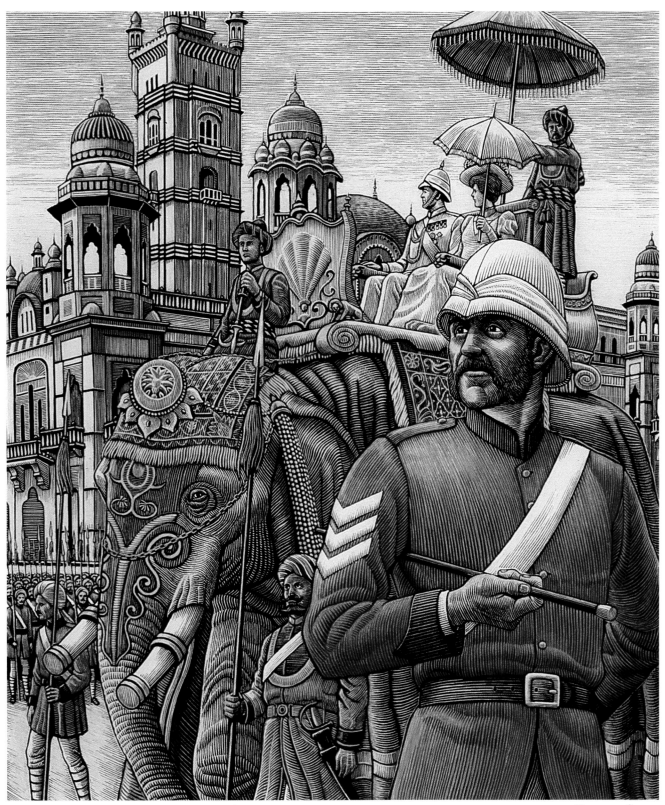

*This artist often works with watercolor directly on the original. In this case, however, several photocopies were made to test out a successful color scheme.*

A

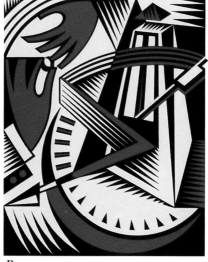

B

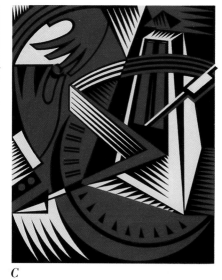

C

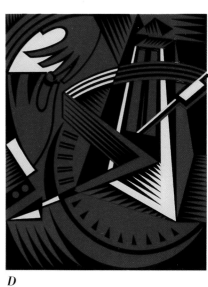

D

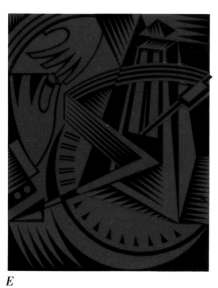

E

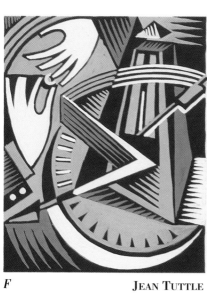

F

JEAN TUTTLE

Each color in this illustration is cut on a separate rubylith overlay with PMS color numbers indicated (B–E); the original baseplate, black-and-white drawing (A); marker on tissue for color indication (F); and the final printed illustration (G).

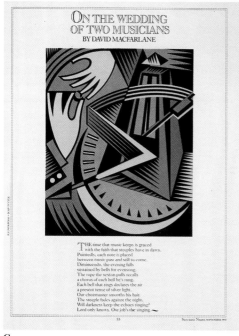

G

# MEDIA

Color illustrations are sometimes simply successful black-and-white illustrations with color added. Color adds definition to the subject and tends to soften the contrast between black and white. Consider your color scheme in advance because adding color may change your drawing method slightly. Since you will apply the color to the exposed white areas of the scratchboard drawing, it is necessary, therefore, to scratch out lines and areas larger than you would if you were achieving the illusion of color only in values of black and white. In fact, you might achieve a dark value of color only later with the paint.

Painting the exposed white areas of a black-and-white scratchboard drawing with watercolor is a commonly used method of applying color. Use watercolors such as Winsor & Newton's, Dr. Ph. Martin's dyes, or Luma dyes. Although the color can look somewhat mottled, especially in large areas, you can see the finished results immediately by working directly with the color. Black scratchboard is perhaps best for this method, since the oil-based black will not smear when you use the wet paint on top of it.

Another common method is to work with rubylith overlays. Label the overlays with the Pantone universal color matching system (PMS), which indicates to the printer by number the color each overlay represents in the final printing. This method is excellent for large flat areas of color with hard edges. It is also less expensive to reproduce hand-separated art than full-color art that has to be photographically separated. The black scratchboard line drawing will be printed last, which helps make registration accurate. The colors indicated can be intense and will hold up well against the strong contrast of the black-and-white drawing and accompanying typography. Large solid opaque areas of color can be cut out of film in minutes. Letratone or Pantone colored films can be cut, laid down, and burnished directly onto the scratchboard drawing to yield the same effect as the overlays, but they allow you to see the color immediately. These illustrations must be separated by the printer, and the resulting black that has been overlapped with a color film will reproduce slightly gray.

Photographically translating the black-and-white scratchboard drawing into a film positive is another popular method. It provides an opportunity to reduce or enlarge the drawing. You can tape the film positive over a baseplate that is painted or collaged with a variety of materials, such as color photocopies, antique patterned papers, or plain-colored cut paper, according to the transferred drawing. Placing the film positive under a thin sheet of opaque watercolor paper on the light table will allow you to work with color in the desired areas. You can also paint with acrylics on the reverse side of the film positive. This composite can then be photographed as a full-color illustration and separated photographically or laser-scanned for reproduction.

Many artists photocopy their illustrations directly onto thin watercolor or

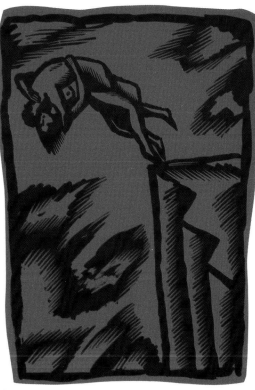

*Often a black-and-white drawing simply surprinted over a colored background will enhance its impact.*

ANTHONY RUSSO

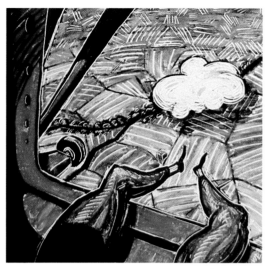

*After the sketch was inked in, the illustration was worked over in oil pastels, then scratched into with an etching tool.*

WILLIAM L. BROWN

etching paper (hot- or cold-pressed works well) or card stock. Then they paint directly on the copy using a variety of media. These papers are much more receptive than the acetate to liquid media and allow for a slow buildup of color.

Another effective technique is to paint directly onto the scratchboard before any drawing or scratching begins, using an airbrush filled with thinned Designers colors or gouache, such as Winsor & Newton's. Painting and scratching and repainting and rescratching in several successive layers is a very successful technique to use for airbrush and Frisket masks. Frisket, a plastic film with a tacky

*This richly textural piece was accomplished by a combination of techniques and media. The white scratchboard was first painted in certain areas with Chartpak ink dyes that soaked through to the base cardboard, staining the chalk surface. After the color coating was dry, the drawing was covered (except for large open areas of color or white) with drafting ink that was then scratched through to the color. The blurred shadows were laid in with airbrush, and the sharp shadows were done with airbrush and Frisket film. Many of the scratched lines were carefully repainted with watercolor or acrylic and a tiny brush. Soft lines were achieved with an air eraser, using aluminum oxide as the abrasive material.*

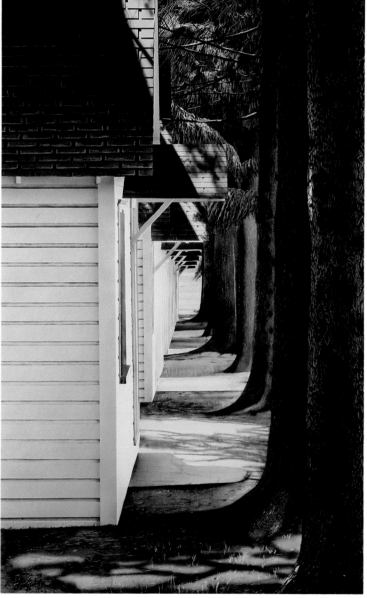

LEE FARLEY

backing, can be easily cut with an X-Acto knife. Cover those shapes to be shielded from the paint with Frisket. The exposed areas, where Frisket has been peeled away, will receive the paint. When the paint is dry, you can remove the remaining Frisket shapes without damage to the surface underneath.

Some artists combine linoleum-cut or woodcut prints with scratchboard. The scratchboard or a photostat of the scratchboard can be inserted into the larger print. The scratchboard can be used for small details and crosshatching effects, and the wood or linoleum for larger, more broadly drawn areas, show-ing off to advantage the roughness of the printmaking medium.

When the clay surface is slightly roughed up with fine sandpaper, colored pencils, such as Prismacolors, Conté, Eagle Berol Verithin, or Faber-Castell, will serve you well. Certain permanent markers applied directly on the surface can be effectively scratched for yet another look. Combining appropriate media for a specific illustration can result in imaginative work that still allows for the characteristic incised line of scratchboard. Take risks and invent new combinations. Your experiments can further encourage your imagination.

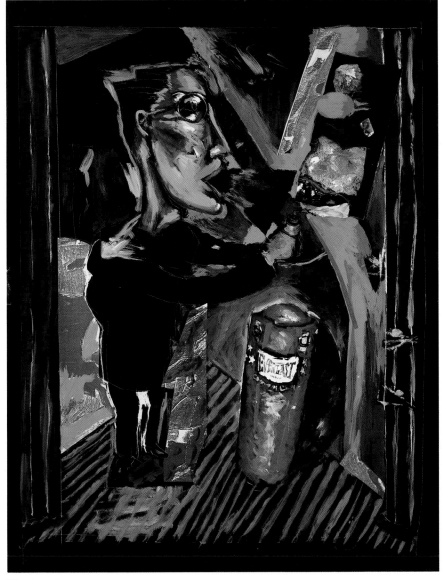

*A free and expressive style was achieved through the use of acrylic and various collaged material, including color photocopies on scratchboard.*

WARREN LINN

*A film positive of the original black-and-white scratchboard drawing was made, and an acrylic painting was done on an illustration board baseplate beneath it.*

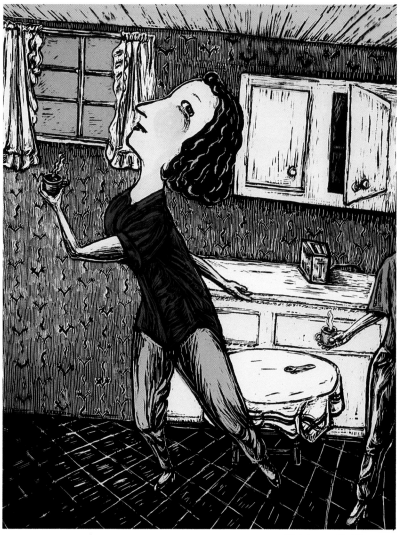

BARBARA E. MURRAY

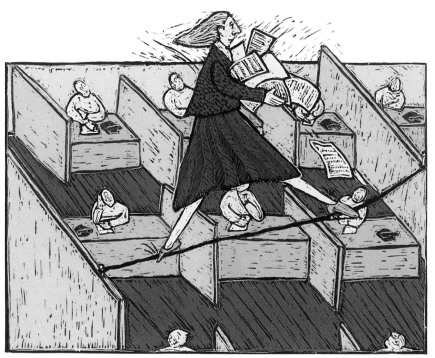

*A single-edged razor blade was used exclusively as the scratchboard tool. The color was laid in with watercolor.*

NELLE DAVIS

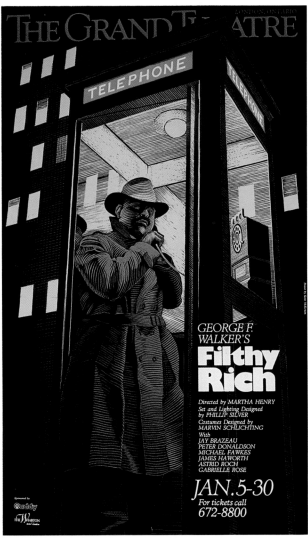

SCOTT MCKOWEN

*These illustrations were printed in flat PMS colors for which rubylith overlays were cut over the black-and-white original. The scratchboard technique gave the poster series a harmonious look.*

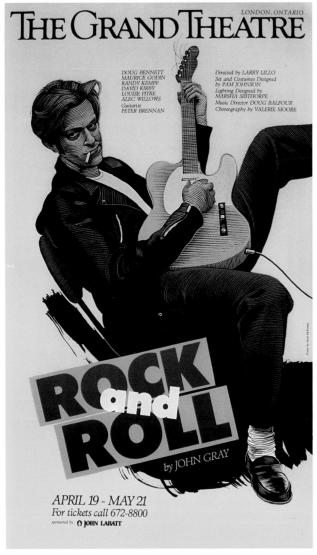

SCOTT MCKOWEN

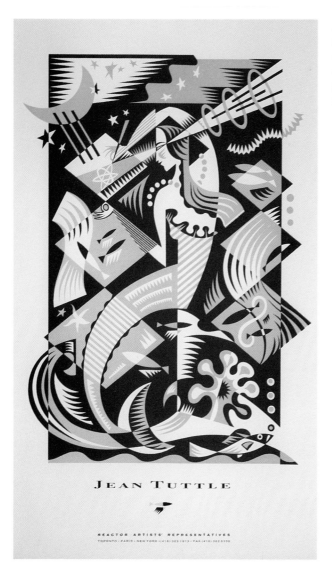

JEAN TUTTLE

In this illustration, the black-and-white baseplate scratchboard art and the rubylith overlay were printed in color on a letterpress.

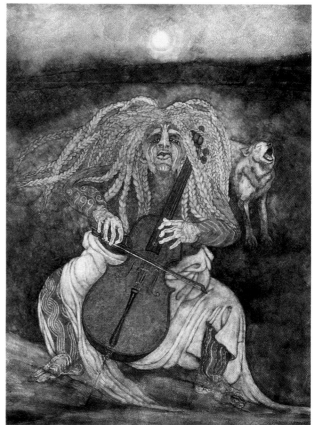

MEINRAD CRAIGHEAD

The scratchboard surface was first sanded with fine sandpaper. Colored inks thinned with rubbing alcohol as well as India ink were used for the painting. The surface was then worked with scraping tools, fine sandpaper, and fine steel wool. When the illustration was finished, acrylic spray was used to fix the surface.

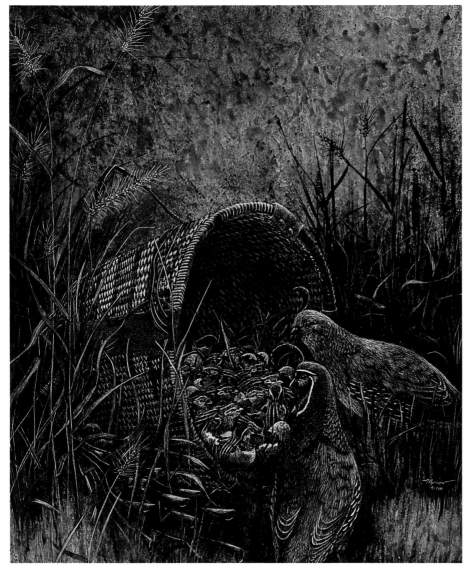

Here, the depth of color was achieved by a layering process of cutting with a knife and then painting these cuts with three transparent glazes of paint: India ink, watercolor, and alkyd glazes alternated with layers of cuts into the clay surface. Alkyds mixed with Liquin and Turpolin (sometimes in conjunction with a liquid mask) were applied with brushes, airbrush, and with found materials in a monoprint technique.

KATHY MORROW

RUTH LOZNER

*In these two illustrations, colored permanent markers were used on white scratchboard. The technique was used to imitate color woodblock prints.*

RUTH LOZNER

CATHIE BLECK

*Handmade papers were used because of their boldness and clarity of color. Flesh tones were put in with dyes.*

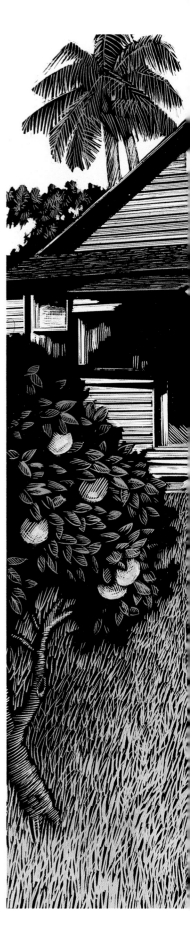

*Here, colored dyes were laid down with brush on white scratchboard. The colored layers were then scratched through with a scratchboard tool.*

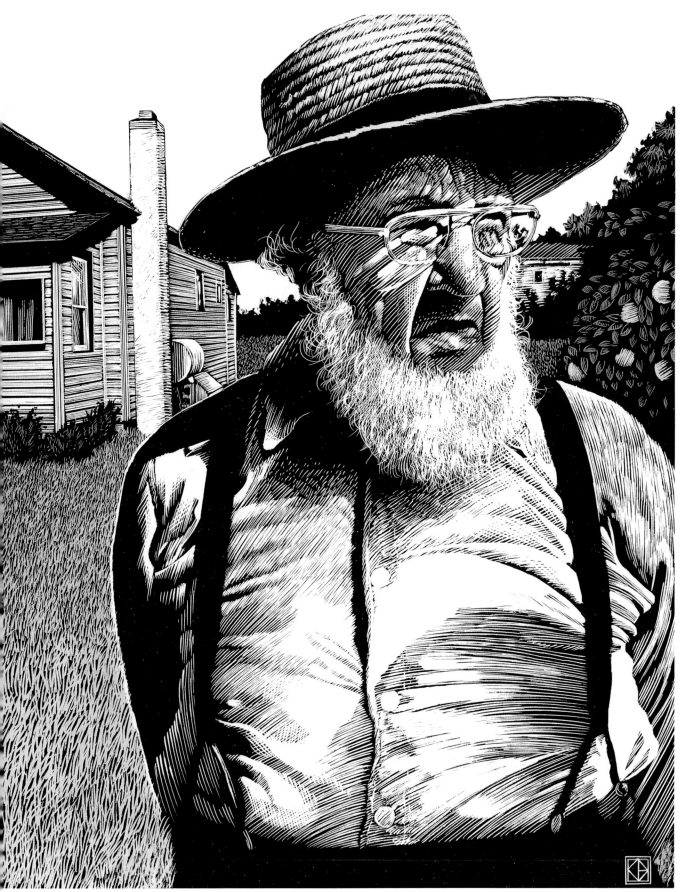

KENT H. BARTON

# HIGHLAND GAMES

## ⊰ Act II ⊱

### T'WERE WELL IT WERE DONE QUICKLY

It was Glenda Jackson who started the whole thing off. Three years ago, she was starring on Broadway in *Strange Interlude*. Glenda, as the *Macbeth* company says in unison, is a real trouper. Cut the star stuff, we are all sisters and brothers. She hears that her dresser, Melinda Howard, has producing ambitions. You find the project, Glenda tells her, and I'll do it. Well . . . Howard had also been

Christopher Plummer's dresser for *Othello*. She knew the magnetism of his big cracked bronze bell of a voice, his noble bones, his sexy, sardonic stage presence. And she knew he was hankering to do another Shakespeare. Those cameo roles in movies and ads for P G Tips tea – "from England, where, goodness knows, they appreciate tea" – might pay for his hobby (he's a frustrated architect who redoes houses) but they didn't feed the soul or boost the ego. A production of *The Taming of the Shrew* had been kited with Plummer and Zoe Caldwell and Peter Sellars, the irreverent young American director who gave his production of *The Mikado* a chorus line of Sony salesmen. But Plummer decided he was too old. *Macbeth* with Jackson – now, that sounded a lot more plausible.

The stars' busy schedules did not coincide until early 1988, when each was finally able to set aside six clear months. Plummer brought in Fran and Barry Weissler, who had produced the successful and profitable

*Othello* on Broadway in 1982. This time, they raised around $950,000 without too much problem: *Macbeth* is popular stuff, the *Oklahoma!* of classics. Audiences gasp as familiar lines zing past: "The milk of human kindness," "Lily-livered boy," "Tomorrow and tomorrow and tomorrow," "Life's but a poor player who struts and frets his hour on stage," "What's done is done," "Out, damned spot!" Almost any audience can clue in fast. And this *Macbeth* has blue-chip actors as well.

The stars, as is usually the case in commercial theatre, settled a long list of directors. Ken Russell was first choice. But he wanted to do *Macbeth* in outer space. Beam me up, Macduff?! No. Plans to use other directors fell through. So the Weisslers decided to approach Kenneth Frankel, the associate artistic director of the respected Long Wharf Theatre in New Haven, Conn. He wanted to do it, says Fran Weissler. "He was really keen," Plummer recalls.

Events now moved fast indeed. The show had to be got up in three weeks for an 11-week out-of-town tour, starting in Stamford, Conn. Frankel had a problem right away: Plummer. He's an outsized actor. "Chris," he says admiringly, "has an approach to language and an energy sadly lacking from the stuff that gets done in the American theatre." Actors were wary of competing with Plummer and, such is the decline in classical theatre, some were frankly waiting for more lucrative TV gigs. So the cast Frankel was able to assemble was at best uneven. In any case, as Frankel understood it from the producers, his first job was to get the show on its feet technically; only after the Baltimore opening in early February would he get to really work with the actors. So the technical line-up was Broadway's best: Patricia Zipprodt, costumes; Otts Munderloh, sound; Tony Walton for sets . . .

The Weisslers, Frankel recalls, wanted a spectacular set. Walton produced a monu-

*continued on page 70*

BILL RUSSELL

*Many illustrators choose to work directly on the white scratchboard using ink for the black line, filling in the white areas with watercolor or dyes.*

*Pure bright color areas appropriately enhance this graphically drawn illustration.*

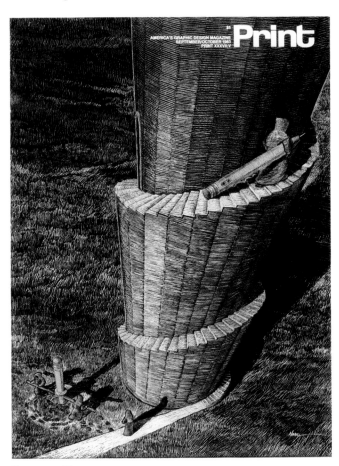

*This piece, on black scratchboard, was painted with watercolor on the original.*

GREGORY NEMEC

TERRY E. SMITH

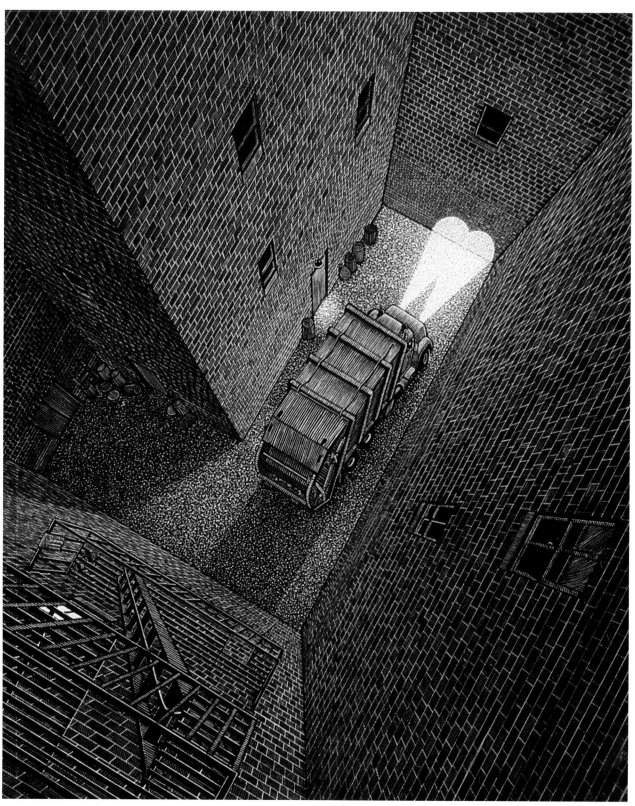

*The overall composition was first scratched in with a fine white line on the black scratchboard. The rest of the drawing was scratched in in progressive stages. The white sketched line was then eliminated by inking over it. The color was added by painting in the white areas with watercolor.*

DOUGLAS SMITH

THE GRAND T

Directed by
MARTHA HENRY
Set & Lighting
Designed by
PHILLIP SILVER
Costumes
Designed
by MARVIN
SCHLICHTING

ERIC WOOLFE

SHAUN AUSTIN-OLSEN    MARK KRAUSE

*in*

# BILOXI
# BLUES

*by* NEIL SIMON

OCT. 18 - NOV. 12
For tickets call 672-8800

Sponsored by
GRAND TOURING CARS
and

SCOTT McKOWEN

*The color was achieved by a combination of airbrush, watercolor, colored pencils, and Pantone overlays.*

Mɪʀᴋᴏ Iʟɪᴄ́

# USING PHOTOCOPIES

Working with good-quality photocopies of black-and-white scratchboard illustration is an inexpensive and efficient way to test out different color schemes.

Once you have decided on a successful color scheme, take a fresh photocopy and begin to paint in the color. Beware that the electrostatic process of photocopying causes the black printed areas to be slightly resistant to the paint. Since the black areas or lines are often close together, you must work a bit harder to get the paper to absorb the paint in those white areas between the lines.

You can use white card stock, which is available in photocopying print shops, but I prefer thin watercolor paper. Be sure to carefully cut any paper to a size appropriate to the machine being used. A good black print on this paper can then be painted with watercolor or dyes.

The reduction and enlargement feature on some photocopy machines will allow you to preview the work in the intended size or even to send the print to the client—if the quality of reproduction is good enough. Finally, this feature of photocopying lets you use a piece in color for publication and retain the black-and-white version for future use.

RUTH LOZNER

*Many photocopies were made of the original black-and-white scratchboard illustration. After several color schemes were tried, the final art was produced with watercolor on the photocopied card stock.*

LIISA RITTER

# CONCLUSION

Illustration, which subscribes to all the basic artistic tenets of the fine arts, has some additional requirements. It *must* communicate a specific message to its audience and it *must* be executed so that it loses little or nothing in impact or integrity in reproduction. Most important, it *must* exemplify the concepts or subject of the assignment. The challenge of illustration is both intellectual in concept and artistic and practical in execution.

Illustrators will gravitate toward certain media for diverse reasons. For emotional, intellectual, instinctual, aesthetic, or practical reasons, some illustrators are drawn to specific media. Others let the subject matter dictate their choice. Still other illustrators respond to the assignment that may require a particular look that can best be achieved by a certain medium. Likewise, the client might select an illustrator because of his expertise in a certain medium or style.

New and different media, tools, and surfaces can also charge the artist with new vitality and present an attractive challenge. A new medium often encourages new forms of stylistic expression. In the last analysis, the illustrator's relationship with a medium is intimate, personal, and unique.

The illustrators in this book have selected scratchboard as their medium of choice. For them, scratchboard embodies the perfect combination of characteristics that inspire them as artists and visual communicators.

I hope this book will inspire you to master your own scratchboard techniques and that the medium will bring with it a new level of artistic satisfaction and professional success.

For your further study and interest, I have chosen to list some of the artists whose work you might examine. Throughout my artistic career, I have looked at countless examples of artists' work for inspiration and edification.

Each artist's particular vision and style has something different to offer. The following artists, who have worked in various drawing, printmaking, and painting media, address issues similar to those discussed in this book. Their work exemplifies a broad range of linear techniques; a sense of drama exhibited through powerful light and shadow; and an individualized style in defining value and tone. Not all of them are traditionally defined as illustrators—the content of their work, however, tends to be narrative, representational, and moving. The list is diverse, eclectic, and, by its nature, incomplete. As you explore art history and art education on your own, take special note of the following:

Lucas Cranach the Elder, Albrecht Dürer, Hans Holbein the Younger, William Hogarth, William Blake, Francisco Goya, Thomas Bewick, George Cruikshank, John Tenniel, Gustave Doré, Edward Burne-Jones, Edward Calvert, Honoré Daumier, Walter Crane, Edwin A. Abbey, Arthur B. Frost, Howard Pyle, Charles Dana Gibson, Laurence Housman, Aubrey Beardsley, Arthur Rackham, Harry Clarke, Käthe Kollwitz, Franklin Booth, Joseph C. Leyendecker, James Montgomery Flagg (who sometimes scratched into the blacks of his pen-and-ink drawings to reveal highlights), John Held, Jr. (who used a medium similar to scratchboard on occasion), Thomas Nast, Henry C. Pitz, Clare Leighton, Rockwell Kent, Raoul Dufy, Franz Masereel, Clifford Webb, Lynd Ward, Georges Rouault, Fritz Eichenberg, and M. C. Escher (who often drew on a surface like scratchboard).

While researching this book, I came across hundreds of wonderful examples of scratchboard illustration, the majority of which were published from the twenties through the fifties. These illustrations appeared in books, in advertisements, in newspapers and magazines,

medical and scientific publications, science fiction, adventure, and wildlife books, and periodicals. While many beautiful scratchboard illustrations appeared anonymously (especially the technical and product illustrations), there are quite a few who were thankfully credited to their creators. Since there has yet to be a compendium of historic examples of scratchboard illustrations, your industry and attentiveness while looking through old publications can be very rewarding.

Look for the editorial and advertising work of the following: T. R. Freeman, W. J. Butt, W. G. Easton, James Lucas, Charles E. Pierce, T. L. Poulton, Edward S. Billin, Charles F. Tunnicliffe, John Farleigh, Walter Kumme, Guido and Lawrence Rosa, Rudolf F. Heinrich, Walter Cole, Irwin Smith, W. Park Johnson, E. Melbourn Brindle, John Richard Flanagan, Paul Calle, Walter Johnson, Stanley Herbert, Eric Fraser, C. W. Bacon, Olga Lehmann, H. G. Collett, the science fiction and fantasy work of Virgil Finlay, the wildlife illustration of Francis Lee Jaques, the medical and scientific illustrations of Max Brödel, Eleanor Frye, Russell L. Drake, and Ralph Sweet. A special mention must go to Merritt Cutler, an artist and author whose fine illustrations and books greatly furthered exposure and popularity of the scratchboard medium.

# LIST OF ILLUSTRATORS

# INDEX